Michael Huber/B. "Moose" Peterson
Nikon N90s/F90X

Magic Lantern Guides

Nikon

N90s · F90X

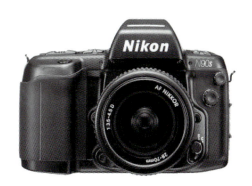

Michael Huber/B. "Moose" Peterson

Magic Lantern Guide to
Nikon N90s/F90X

A Laterna magica® book

English Language Edition 1995
Published in the United States of America by

Silver Pixel Press
Division of
The Saunders Group
21 Jet View Drive
Rochester, NY 14624

From the original German edition by Michael Huber
English language version by B. "Moose" Peterson
Translated by Hayley Ohlig
Edited by Peter K. Burian
Production Coordinator, Mimi Netzel

Printed in Germany by Kösel GmbH, Kempten

ISBN 1-883403-20-0

Contents

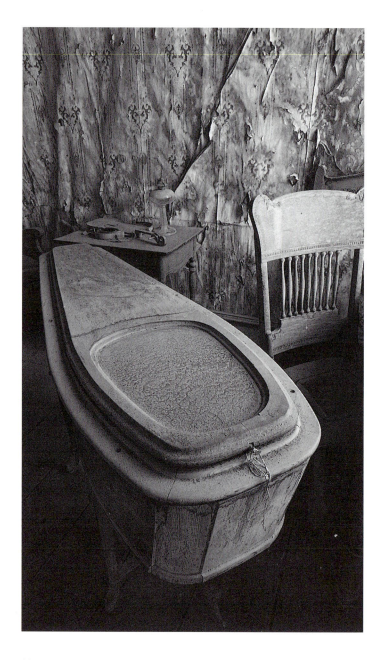

Introduction

At Photokina '92, the N90/F90 was introduced. It was the first of a new camera generation and filled a niche in the Nikon line between the N8008s/F-801s and F4. In the fall of 1994, Nikon introduced the N90s/F90X. Significant advances, especially in software programming make the N90s/F90X one of the fastest auto-focus systems on the market. Other changes, including a faster motor drive and expanded processing capabilities, also contribute to making the N90s/F90X a substantially improved camera.

This book is based on more than a year of practical use with the N90/F90 and many weeks with the N90s/F90X. The authors, the editor, several photo enthusiasts and an experienced professional were involved in the research which brought this book to fruition. In the fall of 1994, this book was technically edited, amended and revised. We also added information on the new N90s/F90X released at that time. Unless otherwise noted, the text refers to the operation of all N90/F90 series cameras, both the original and the new "s" or "X" version. Differences between the models are fully explained where applicable.

While there is some confusion over the F90D and F90S designations, these refer to the original F90 body equipped with a Data Back or a Multi-Function Back, respectively. These versions are not available in North America, although the backs can be purchased separately as options.

Note: When two camera designations are listed, for example N90s/F90X, they refer to the U.S. and international model names for the same camera.

An N90s with a 24mm lens was used to capture this abandoned parlor in a ghost town.

N90s/F90X Features

In this chapter you will find an introduction to some of the most important facets of the N90s/F90X, relevant to the N90/F90 as well. While the following subsections provide an introductory overview, many of the possibilities mentioned will be explained fully in subsequent chapters.

Unique Features: The N90s/F90X retains and improves on important features of other Nikon cameras. It offers photographers an amazing degree of control of automatic features, plus a full complement of overrides and manual modes allowing the photographer to exercise his own creativity. The new N90s/F90X is designated as a "pro" camera. Consequently it has improved dust and moisture seals providing it with 50% of the environmental protection of the F4.

One of the advantages of the new N90s/F90X is the ability to select shutter speeds in 1/3 stop increments in Manual, Shutter Priority and Flexible Program modes. With ambient light or flash, the photographer gains more precise control over exposure or the depiction of motion. However, as with other Nikon cameras (except the N50/F50), the aperture is controlled by a mechanical ring on the lens, except in Flexible Program mode. Hence, the f/stop can be set only in full and half stops - except when shifting aperture/shutter speed combinations in Flexible Program mode.

Ergonomic Design: Those functions that are needed while the camera is at your eye can easily be reached on the N90s/F90X (subject to the size of the user's hands and fingers, naturally). Compared to the N8008s/F-801s, the N90s/F90X offers improved functioning in important details: the new AF-mode switch, illuminated LCD display, and (with Data Link) programmable shut-off

This picturesque reproduction of a Scottish landscape was taken with a 20mm lens and T-Max 3200 film processed to enhance the grain. A special soft-focus filter was used during printing to create a slight haze effect. Picture: Wolf Huber

This candid snapshot of a farm worker in Madeira demonstrates modest depth of field with a sharp subject and slightly blurred background.

time and numerous other options. The N90/F90 featured a warning beeper but this has been omitted on the N90s/F90X.

The MB-10 Multi Power grip makes a big difference in handling of the camera. Its larger size and second shutter release button vastly improve comfort and convenience of operation. It also has a slight effect in balancing out the camera's weight when using a longer lens; this should result in sharper photographs. The MB-10 is compatible with the earlier N90/F90 but the secondary shutter release does not function with that model.

Professional stability: The N90s/F90X is a professional-level camera. This is obvious in that it has a heavier and slightly larger body. In keeping with the practical need for robustness, Nikon did not use smaller, lighter plastic construction in either the N90s/F90X or

These architectural details from the Saracenic period confirm that the AF system has no difficulty with patterns of any type. However, set focus for the desired point, and recompose with AF lock.

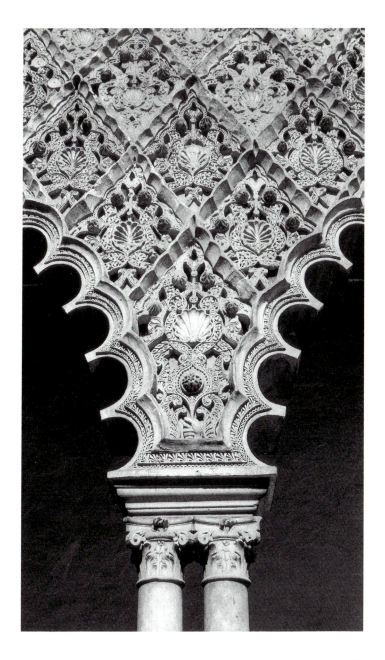

the new AF-Nikkor D-type lenses. And while the experienced photographer will inevitably complain about the weight of the photo gear he or she has to lug around, he or she undoubtedly values the advantages of the more solid cameras. Slightly larger and heavier models feel more substantial, while the increased heft adds a stabilizing force which helps assure sharper pictures.

Lens compatibility: All N90/F90 series cameras are compatible with the full range of the new AF-Nikkor D-type lenses with the accompanying 3D Matrix metering (Distance Data Detection) and more sophisticated flash exposure control. They can also take advantage of the lightning fast focusing speed of the modern AF-I Nikkor lenses with their built-in motors, a function possible only with these cameras and the F4. Naturally, all the previous AI and AI-S Nikkor lenses are compatible with manual focusing and center-weighted or spot metering. Non-AF Nikkor lenses that are f/5.6 or faster can take advantage of the focus-assist indicators in the viewfinder. When a manual focus lens is used with the AF tele-converter TC-16A, autofocus is possible with fixed focal length lenses: those with a maximum aperture greater than f/3.5.

Autofocus System

The autofocus system on the N90s/F90X is faster and more accurate than any other Nikon camera, including the N90/F90 or F4. Predictive Focus Tracking operates at speeds up to 4.1 fps, as compared to 3 fps with the N90/F90. This improvement was made possible by a new coreless motor (capable of 4.3 fps), a more effective micro processor and a new set of "algorithms" (a formula for solving mathematical problems).

Focus tracking: Nikon's term for "predictive autofocus", it is always active on the N90s/F90X. When a subject within the focus detection brackets (marked on the viewing screen) begins moving, Focus Tracking is automatically activated. The system calculates its speed and sets focus for its probable position at the instant the shutter curtain opens. The N6006/F-601, N8008s/F-801s, N70/F70, N50/F50 and F4 already offered this feature, but only in Continuous AF mode.

Selective AF area: One of the main complaints professional Nikon users have had is the relatively small size of the focus detection area on the N8008s/F801s and F4. We cannot completely agree, although the argument that an autofocus system works more reliably with a larger focusing area is valid. The question is whether or not it focuses on the spot the photographer actually wants. A larger focusing area simulates the snapshooter mentality to focus on the most obvious point. Meanwhile, a smaller autofocus area better suits the pro or the advanced amateur who specifically wants to focus on a certain point. In our experience, the wide area focus sensor was useful primarily when tracking motion, reducing the risk of "losing" a small target. Regardless, the narrow area Spot AF sensor is definitely preferable when the exact point of focus is important. Otherwise the system will select the closest or the brightest target in a scene, and this may not be the desired area of maximum sharpness. Those who do not concentrate as carefully when focusing will no doubt have greater success with the wider focus detection area. It also offers advantages with 3D Matrix metering as well as 3D Matrix balanced auto-flash. In either case, the cross field-sensor is capable of recognizing an infinite variety of patterns. Its 172 horizontal zone (7 mm wide) and 74 vertical CCDs (3 mm in size) are sensitive to horizontal, vertical and angled lines with equal accuracy.

Higher AF speed: The fact that the N90s/F90X autofocus system is somewhat faster than that of the N90/F90 or the F4 is due not only to the particularly fast AF motor, but also to the expanded mathematical capabilities of the camera's CPU (Central Processing Unit). A newly simplified and hence particularly fast formula, commonly referred to as "Fuzzy Logic," was developed for the camera. The N90s/F90X's autofocus system provides a noticeable improvement. Focus

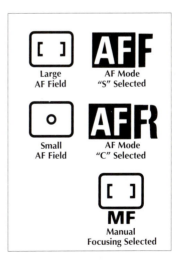

Large AF Field — AF Mode "S" Selected

Small AF Field — AF Mode "C" Selected

Manual Focusing Selected

detection, focus motor drive, and focus tracking have all been enhanced, "with the lens driving mechanism 25% faster than the N90/F90", according to Nikon.

Advanced Metering System

Just like the N8008s/F-801s and the F4, the N90s/F90X offers Matrix, spot, and center-weighted metering options.

Improved Matrix: Unlike the N8008s/F-801s and F4 which evaluate brightness and contrast in five segments, the N90/F90 series cameras consider eight segments. The advantage of three additional segments in the center of the image is that correct exposure of the subject will be even more likely. In our tests, however, these three additional points could not improve the result in certain critical cases, like pictures with lots of bright sky or with dark subjects.

3D Matrix: With D-type AF Nikkor lenses, the N90s/F90X uses the autofocus system to determine how to weight the various segments. In other words, the systems can determine when your subject is off-center, and its distance. It will add this information to the metering equation, and optimize exposure for the appropriate section of the image, and type of subject. Its pattern is adjusted for extreme close-ups, for example. In our tests 3D Matrix metering performed exceptionally well, but was extremely successful with conventional AF lenses in standard Advanced Matrix metering as well.

Exposure Modes

Subject-Specific Vari-Programs
The N90s/F90X offers seven Vari-Programs that determine the optimal shutter speed/aperture combination and overall exposure based on subject type: portrait, landscape, silhouette, action, close-up, etc. However, our tests showed that an experienced photographer, when given enough time to consider the subject, is often better than the program modes on the N90s/F90X. This is

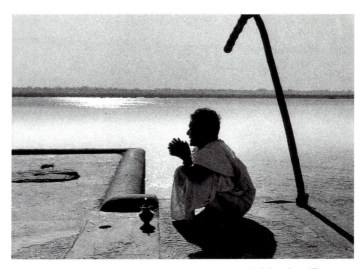

A scene such as this (Benares on the Ganges) is ideal for the Silhouette Vari-Program of the N90s/F90X.

definitely a function of the difference between human and computer "intelligence." The experienced photographer knows what to do in borderline cases. For a sports shot with an exposure time between 1/250 and 1/500, do I take the faster or slower one? The computer has a 50/50 chance of being wrong. In the end, only the photographer knows what is more important: more blur or greater sharpness in any situation.

On the other hand, inexperienced photographers (or anyone working quickly) inevitably will make mistakes from time to time. In these situations, one of the Vari-Programs is practically infallible: even in extreme cases, it rarely deviates more than one f/stop or shutter speed from the combination which is ideal for the situation. Mind you, the photographer selects the program according to his or her level of experience. To do so, you need certain information which you will find in the appropriate chapters of this book.

Flash Photography

The shutter and the electronics of the N90s/F90X allow flash sync speeds from 30 seconds to 1/4000 second. For long flash exposures,

we recommend second curtain sync, for reasons discussed in detail later in the text. Through this feature, the N90s/F90X can use automatically controlled flash, not only to achieve pleasing exposure, but also to produce blurred effects or to freeze motion. Using the exposure modes "P" and "A," the N90s/F90X programmable "Slow" flash mode allows exposure times of up to 30 seconds, a great feature for creating motion blurs or to allow city lights in the background to register on film for a brighter look.

Second Curtain (REAR) Sync: The ability to synchronize the flash with the second (rear) shutter curtain is very useful. This function can be selected on the N90s/F90X. REAR sync is recommended for long exposures (down to 30 seconds) to produce an effect which appears "normal" to the viewer's eye.

Compatible Flash Units: If you want to utilize all of the N90s/F90X flash functions, you'll need an SB-25 or SB-26. Practically all modern Nikon System Speedlights can be used with the N90s/F90X, but depending on the model, certain functions (such as red-eye reduction) will be unavailable.

Special Accessories for the N90s/F90X

Eyepiece Adapter DK-7: To attach the waist-level viewer DR-3 or magnifying loupe DG-2.

Eye Cup DK-6: For more comfortable use, also serves to protect eyeglass lenses.

Viewfinder Screens: Type E screen has a 12 mm central circle, 2 AF focus brackets, and a vertical/horizontal grid on a fresnel lens. For reproduction work, architecture, and extreme wide-angle lenses.

Using flash indoors is not always desirable or permitted. Switch to an ISO 400 or 1000 film if needed, and brace the camera on some firm support.

External Battery Holder DB-6: With a six "AA" battery capacity, there is enough power to shoot approximately 10 times as many exposures. Ideal for continuous use in scientific documentation and high-speed sports photography.

MB-10 Multi-Power Vertical Grip: This attaches to the bottom of the camera and provides the ability to use either four AA batteries or two 3 volt lithium batteries. With the N90/F90, the secondary shutter release is not functional as the camera lacks the necessary contact point.

Remote Release MC-20: For electrical remote triggering and long exposures ("T" shutter). It has a built-in timer and light for long exposures at night. Runs on battery power from the camera body. The now discontinued MC-12A cable release, in conjunction with the adapter cable MC-25, will also work with the N90/F90 series. Two cameras can be simultaneously triggered using the MC-23 cable.

Data Back MF-25: Adds a choice of the following imprinted on the film frame: 1) Year, month, and day. 2) Day, hour, and minute.

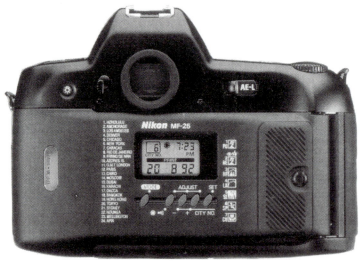

Data Back MF-25

3) Day, month, and year. 4) World-time function. Also provides an alarm.

Multi-Control Back MF-26: The MF-26 replaces the standard back of the N90s/F90X and provides twelve functions not available otherwise. The functions are: World Clock, Data Imprint function, Long Time Exposure function, Auto-Sequence Shooting function, All-Mode Exposure Bracketing function, Flash Exposure Bracketing function, Multiple Exposure function, Interval Timer function, Focus Priority function, AE/AF-Lock function, Custom Reset function and Flash Output Compensation function. Greater detail of operation is provided later.

Data Link System: With the Data Link, using a SHARP Wizard EO (electronic organizer) the N90s/F90X can be completely controlled by remote and can even be programmed. The N90s/F90X uses the new AC-2E and the N90/F90 uses the AC-1E card. The AC-2E works with the N90s/F90X feature of 1/3 shutter speed selections. In addition, the 12 most important variables of each shot can be recorded. This makes the N90s/F90X the ideal camera for documentation in science and research, in reproduction photography, for shooting a series of exposures in advertising, etc. Looked at in this light, the N90s/F90X and Data Link that appeared to be too expensive at first glance suddenly have a good price/features ratio.

N90s/F90X Camera Controls

All functions and values are set by electronic impulses on the N90s/F90X. By pressing the appropriate function button and simultaneously turning the input control dial, the desired value can be set or the desired mode selected. The following chapter should quickly help you understand the functions of the N90s/F90X in detail. Since you have invested in the camera, it would be a shame to only make use of a small portion of its potential. We recommend that you use this chapter as a crash course, with camera in hand, and try everything immediately.

The Camera Body

Front

Let's examine the N90s/F90X closely, with the lens removed. Front left, at the top edge of the handgrip, you will see a rectangular, red LED window which is the self-timer indicator. Front right, at the outside edge of the bayonet mount, you will find a black lug attached to a rotating ring. This is for the mechanical aperture transmitter, necessary when using non-AF lenses. Slightly below this is a white dot. Line this up with the white dot on your lens to correctly align the two. To its right are two screw caps. The upper cap conceals a flash sync socket, and under the lower one is a 10-pin connector for Data Link and remote trigger. This connector is only compatible with the new cable release MC-20. In order to use the old MC-12A cable, the adapter cable MC-25 is required. Halfway up the camera body to the right of the lens mount is the lens release button. The AF mode selector (for selecting Manual, Single Servo AF or Continuous Servo AF) is located directly below it.

Manual focus mode "M": For manual focusing. You can use the focus confirmation indicator in the viewfinder to aid in focusing with lenses of f/5.6 or wider maximum aperture. PC-Nikkors, Reflex-Nikkors, and slower lenses can be focused manually by using the matte focusing screen.

Single Servo AF mode "S": Shown as AF + F on the LCD panel. This mode is based on focus priority. That is, even if the shutter release button is completely depressed, the shutter will only be released when the image is completely sharp.

Automatic focus lock in "S" mode: With a stationary subject, focus can be achieved by touching the shutter release button and will remain locked as long as pressure is maintained. The composition can therefore be altered without changing the focus. To expose, completely depress the shutter release button.

Continuous Servo AF mode "C": Displayed as AF + R in the LCD panel. This mode is based on exposure priority. As long as the shutter release button is partially depressed, the autofocusing system continually adjusts to follow the subject. When the button is completely depressed, an exposure will be made, even if the image happens not to be perfectly sharp. The disadvantage of C mode therefore, is the risk of out-of-focus pictures. The advantage is that the focus is constantly adjusted while panning or tracking any moving subject.

Tracking/Predictive autofocus: Located inside the bayonet ring of the N90s/F90X, on the upper inside edge, are 7 contacts that electronically transmit lens variables. The lens ROM microchip transmits the values for maximum aperture, set aperture, focal length, and distance (the latter only with D-type AF Nikkors) to the camera. The camera's CPU uses these values to calculate the correct values for focusing and exposure. In the middle of the left inner edge of the camera, inside the bayonet, you will find the spring-loaded aperture lever. This lever sets the working aperture on the lens when an exposure is made. You will see a hole in the bottom left of the bayonet mount where the drive shaft for lens focusing connects to the lens. *Do not ever touch any of these extremely delicate components.*

Depth-of-field preview button: Outside the bayonet ring on the left side is the depth of field preview button. When this button is depressed, the lens closes from wide open to the working aperture to enable visual confirmation of the depth of field in the viewfinder. (The viewing screen darkens but your eyes should adjust in

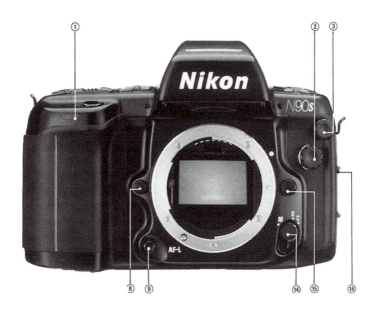

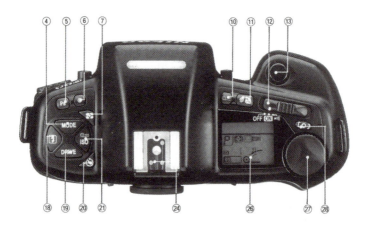

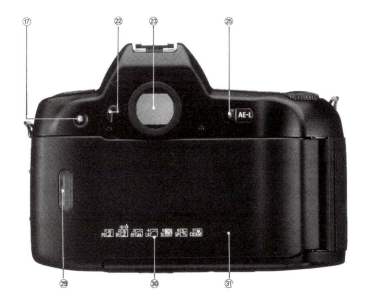

N90s/F90X Operating Functions

1. Self-timer LED
2. 10-pin Remote Control Connector
3. Sync Connector
4. Exposure Mode Selector Button
5. Vari-program Button
6. Reset Button
7. Metering Mode Selector Button
8. Depth of Field Preview Button
9. AF Lock Button
10. Rewind Button
11. Exposure Compensation/ Reset Button
12. Main Power Switch
13. Shutter Release Button
14. Focus Mode Selector
15. Lens Release Button
16. Camera Back Release
17. Viewfinder Illumination Button
18. Flash Sync Mode Button
19. Film Transport Mode Button
20. Self-timer Button
21. Film Speed/Rewind Button
22. Eyepiece Shutter
23. High-eyepoint Viewfinder
24. Accessory Shoe
25. Autoexposure Lock Button
26. LCD Panel
27. Command Dial
28. AF Field Size Button
29. Film Cartridge Confirmation Window
30. Vari-program List
31. Camera Back

a few seconds). However, this button may only be used in "A" and "M" modes. Below this, on the lower edge of the camera, you will find the AF-L Button. When depressed, the last focus setting is locked-in. This is useful in Continuous autofocus mode when you decide to lock focus on a particular point.

Back

If you open the back of the camera, you will see the camera back locking mechanism on the far left and beside it, the film cassette chamber. The slotted rewind shaft protrudes into this bay. On the right are the DX contacts, which automatically read the DX-coded film speed off the film cassette. In the middle of the camera you can see the shutter blades. Never touch these blades as they are very sensitive and can be easily damaged. To the right of the shutter, you can see the auto film loading mechanism. It consists of the film transport sprocket wheel and the take-up spool. The red markings on the bottom indicate how far the film has to be pulled out of its cassette to be loaded. Located on the camera back are the film guides and the film pressure plate. This plate is very sensitive and can easily be knocked out of alignment, resulting in poor film flatness and a loss of sharpness.

Top

At the top of the camera is the prism finder. With its high eyepoint design, the viewfinder can be used from a slight distance, thanks to specialized optics. This feature is very important for photographers who wear glasses. Also available for the eyepiece are corrected diopters, an eye cup, and a magnifier. On the left side of the eyepiece, you will see the eyepiece shutter lever. Still farther left is the LCD panel illumination button which turns the panel's lights on for about 8 seconds.

The Autoexposure Lock (AE-L) lever is located to the right of the eyepiece. When this lever is pressed to the left and held, the exposure value that was last measured will be stored, in all modes except "M." This value will be used for the next shot, even if the scene has changed, after recomposing, for example.

When the camera back is closed, you can always see if there is film loaded and its type by looking through the film cassette confirmation window. On the standard camera back, there is also a list of the Vari-Program symbols.

Catching spontaneous action is easily achieved with the Sport Vari-Program.

On the left side, between the button cluster and the viewfinder, you will find the self-timer button. To set the self-timer, turn the Command Dial while pressing this button. Times are variable between 2 and 30 seconds. A second self-timer exposure can also be selected. The second exposure will be made 10 seconds after the first. Symbols on the LCD panel will guide your selection.

To the top right of the button cluster, you will find a button bearing the Matrix metering symbol. This button allows you to select one of the three metering modes, by pressing it while turning the Command Dial:

Matrix: Represented by a large rectangle divided into 5 segments.
Spot: Represented by a small dot in a rectangle.
Center-weighted: Represented by a dot in a circle, both within a larger rectangle.

The Program Selection (PS) button is located on the front edge of the camera. This button will access the Vari-Programs, sometimes called subject-specific programs. There are seven such programs:

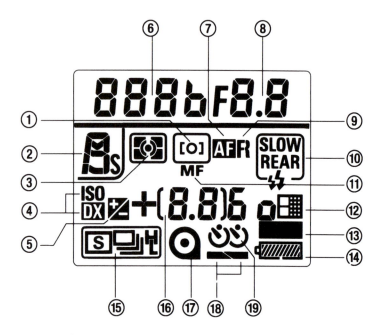

LCD Readout

1. Auto Focus Area
2. Exposure Mode
3. Metering Mode
4. ISO/DX Indicator
5. Exposure Compensation
6. Shutter Speed
7. Autofocus
8. Aperture
9. Release/Focus Priority
10. Flash Sync Mode/ Red Eye Reduction
11. Manual Focus
12. Electronic Organizer *

13. Custom
14. Battery
15. Film Advance Mode
16. Frame-counter/ Vari-program/ISO Speed/ Self-timer Duration/Exposure Compensation Value
17. Film Loading
18. Film Advance and Rewind
19. Self-timer

Appears only when Data Link System is un use.

1) "Po" Portrait. 2) "rE" Portrait with flash and red-eye reduction. 3) "SL" Silhouette. 4) "HF" Hyperfocal (maximum depth of field). 5) "LA" Landscape. 6) "SP" Sport. 7) "CU" Close-up.

At the left side of the main switch and beside the LCD panel is the function key for manually selected exposure correction (+/- symbol). When this button is pressed, the set exposure correc-

tion value is displayed on the main LCD panel. The value can be changed by turning the Command Dial. When the button is released after selecting, the exposure correction symbol appears as a reminder in both the main LCD and in the viewfinder (+/-). The numerical value of the correction will only be displayed by pressing the +/- button on the N90s/F90X. The green dot on the +/- key indicates that this button doubles as the reset key. If this button and the reset key (the green button on the other side of the viewfinder) are pressed simultaneously for approximately 1 second, the camera resets to its default settings (program mode, Matrix metering, wide autofocus detection field, and AF mode "S"). To the left of the reset button is the film rewind button, which is marked in red. When this button is pressed at the same time as the film rewind button in the button cluster, film rewind is activated, even in mid roll.

On top of the pentaprism is the accessory hot shoe with the flash contacts. All of the flash functions from the N8008s/F-801s and F4 are possible with the Nikon SB-20, SB-22, SB-23, SB-24 flashes. A set of special N90s/F90X functions are only possible with the SB-25 and SB-26, and some of these only with Nikkor D-type lenses.

The LCD Panel
This is located to the left of the Command Dial. All the actual values and functions are displayed simultaneously, while the LCD readout in the viewfinder is limited to the most important information.

Top row: Here, exposure values are displayed; on the left the exposure time (including B, under, and over-exposure warnings), and on the right the aperture (f/stop). This line is only active when the shutter release button is touched.

Second row: Continuously displays the following from left to right: exposure mode, metering system, and the selected AF focusing area. Temporarily displayed is the AF mode (S, C, MF) and the flash modes (normal, preflash, slow and rear curtain sync).

Third row: Continuously displays the frame counter, ISO, exposure correction factor, self-timer duration, and the selected Vari-program, depending on which function key is touched. At the end

of the row is a symbol for the connected Electronic Organizer and a display for programs entered via Data Link.

Bottom row: A constant display of the motorized film advance mode (S, L, H). Beside this is a symbol which indicates if film is loaded and another which indicates film transport. If these symbols flash, the film is either torn or jammed. When the self-timer is activated, a clock symbol is displayed here. At the end of the row is the battery power indicator which is only active when the shutter release button is slightly depressed.

The Button Cluster
To the left of the pentaprism, where traditional cameras have their rewind knob, you will find the function button cluster that controls the camera's main functions.

MODE: With this button, you can select the exposure mode with the Command Dial:
- ❏ **"A"** represents aperture priority: a shutter speed is automatically set in accordance with the manually selected aperture.
- ❏ **"S"** stands for shutter priority: manually set a shutter speed and the camera automatically selects the correct aperture.
- ❏ **"P"** is the Auto-Multi Program mode. Here, the camera selects both the shutter speed and aperture, depending on the focal length of the lens. The longer the focal length, the faster the shutter speed in order to prevent motion blur. In addition, it is possible to manually change the aperture/shutter speed combination *while maintaining equivalent exposure!* Simply rotate the Command Dial for Flexible Program. For example, if the LCD panel shows f/5.6 at 1/250, you can select f/4 at 1/500 to freeze a moving subject, or select f/8 at 1/125 to increase depth of field with a stationary object. The program change is displayed by P* on the LCD panel and in the viewfinder.
- ❏ **"M"** stands for manual exposure. This means that the aperture can be selected on the lens' aperture ring and the shutter speed can be freely selected via the Command Dial. An evaluation of the exposure is shown in the viewfinder and on the LCD panel using a bar graph in 1/3 stop increments. These indicate whether you are over- or underexposing from the meter recommended value.

ISO: This button is used to set the film sensitivity, between ISO 6 and ISO 6400 or automatic DX (displayed on the LCD panel). To set, simultaneously press the ISO key and turn the Command Dial. It is necessary to manually set the film sensitivity if the film cartridge is not DX-coded or if you would like to deliberately under- or over-expose an entire roll of film (for example, set a higher film speed and request "push" processing of color slide or b&w negative film, under poor lighting conditions). If DX is selected, the film sensitivity will be automatically set (between ISO 6 and ISO 6400) when using DX coded film canisters. The DX symbol will appear on the LCD panel along with the film sensitivity when film is loaded. It is essential to check if the film speed is correct, every time you load a new roll. An error could result from dirty or imperfect connections, or you may have set some other film speed for the previous roll. The film speed (ISO) button has a secondary function. When pressed at the same time as the film rewind button, the two will activate rewind.

DRIVE: The motorized film transport settings can be selected using the DRIVE key and the Command Dial:

- ❏ **"S"** stands for "single" and allows one exposure per depression of the shutter release button.
- ❏ **"L"** represents slow continuous shooting. In this mode, as long as the shutter release button is held down, the camera will expose approximately 2 frames per second.
- ❏ **"H"** represents high speed continuous shooting. In this mode, as long as the shutter release button is held, the N90/F90X will expose approximately 4.3 fps and 4.1 fps in Tracking Focus. With the N90/F90, maximum advance is 3.6 frames per second, slowing to about 3 fps in Tracking Focus.

These fps (frames per second) values are valid for shutter speeds faster than 1/250 second, normal temperatures, and fresh batteries. Thanks to Tracking AF, it is possible to shoot just over 12 frames in three seconds with the N90s/F90X. It is not possible to fire faster since the camera would not have enough time to focus. A faster motor drive is therefore not the answer in autofocus mode.

FLASH: The button at the far left of the cluster is the flash button. This allows the user to switch between the many flash functions

of the N90s/F90X. The normal setting is the simple flash symbol in the LCD panel. In addition to spot metering or center-weighted metering, Multi-Sensor TTL flash metering is possible with AF Nikkor lenses. In conjunction with Advanced Matrix metering, the camera automatically considers ambient light and contrast and produces a finely balanced fill-flash. With D-type AF Nikkor lenses it even considers the distance to the subject for maximum accuracy in 3D Matrix).

The second option (denoted by double lightning bolts or an eye, depending on the model) provides red-eye reduction. This option is available in all metering and exposure modes only when using the SB-25/26 Speedlights. The SB-25 produces a pre-flash while the SB-26 illuminates an incandescent bulb.

The next setting is the slow flash sync function, represented by "SLOW" in the LCD panel. Using normal flash sync, the exposure modes "A" and "P" select shutter speeds between 1/60 and 1/250 second, depending on the available light. Switching to "SLOW" increases the shutter speed time up to 30 seconds (basically permitting ambient light dark backgrounds adequate time to register on the film).

The "REAR" setting synchronizes the flash with the second shutter blade. If selected, the flash will be triggered at the end of a long exposure and not at the beginning, as is usual. This way, motion blur is much more natural: following instead of preceding a moving subject as with first shutter curtain sync. In auto-exposure modes "A" and "P," flash synchronization will be automatically switched to "SLOW," since "REAR" does not make sense when shutter speeds are 1/60 second or faster.

Note: On the SB-24 and SB-25/26, this function must be selected on the flash unit itself; the camera's control is required for other Speedlight models, however.

The Handgrip

At the top of the handgrip is the shutter release button (no cable release thread). This is a multi-function button, touching it very gently turns on the exposure electronics. Extra pressure activates the autofocus systems; completely depressing the button exposes the film and automatically advances it to the next frame. The camera's main power switch is behind this button, on the right.

With the N90/F90 - but NOT with the newer N90s/F90X - the far right position provides a beeper to confirm focus, warn of camera shake in certain modes, etc.

Directly behind this, you will find the focus area button which allows you to switch from wide (7 mm) to narrow Spot focus detection areas. On the back edge of the handgrip is the Command Dial often used to change aperture and/or shutter speed. By simultaneously pressing a function key and turning this dial, you can change the value or mode of certain functions. For example, if the MODE button is depressed, you can change from Program to Manual control by turning the Command Dial.

The battery compartment lid is located on the underside of the camera at the bottom of the hand-grip. Located in the middle of the base plate on the lens axis is the 1/4"-20 tripod mounting socket. The serial number of the camera is also engraved on the bottom.

The High-Eyepoint Viewfinder
The N90s/F90X's viewfinder is the same as that found on the N8008s/F-801s and is therefore the very best available. In addition to its eyeglass-friendly design, it houses several other important features.

A useful accessory for people who do not like shooting while wearing glasses is an eyepiece correction diopter. However, with the Nikon's high-eyepoint finder most prefer to keep wearing their eyeglasses.

Eyepiece shutter: The built-in eyepiece shutter of the N90s/F90X prevents stray light from entering the viewfinder, where it could adversely influence the light meter reading. This is indispensable for long exposures in automatic mode when the eye is away from the eyepiece.

Interchangeable focusing screens: The N90/F90 series comes with the universal focusing screen Type B. This bright, contrasty focusing screen is outstanding. The particularly even and fine-grained surface permits focusing even under low light conditions or with slow lenses. Etched onto the focusing screen is a small circle that represents the Spot autofocus field as well as the spot metering area. The larger rectangle represents the wide area focus detec-

tion field. (This central area contained by these two symbols approximates the three central exposure metering segments of the N90/F90 series' Matrix metering.) The large central circle indicates both the 75% weighting of center-weighted metering and the central metering segments in Matrix mode.

If desired, the screen can be exchanged with a Type E screen that has a grid of horizontal and vertical lines. This screen is recommended for constant use by professionals since it is always useful whether one wants to judge converging lines, line up original prints and copy work, or check magnification scales.

The Viewfinder Display
When the shutter release button is touched lightly, the green backlit LCD array appears. This stays on for approximately 8 seconds after the shutter button is released. The focus detection area size is shown at the far left hand side of the viewfinder display. Beside it is the focus confirmation indicator (arrows and dot), followed by the selected exposure mode and the actual f/stop and shutter speed. With the N90/F90, exposure times and apertures are rounded to the nearest whole number on the display.

The N90s/F90X provide shutter speeds in 1/3 steps, as mentioned earlier. However, both models do use fractional values for internal calculations in all but Manual Mode: stepless apertures (such as f/4.3, f/14, etc.) and stepless shutter speeds (such as 1/19 sec., 1/567 sec., etc.). An additional bar graph (analog display) appears at the right side of the panel but only in Manual "M" mode. This provides an indicator for under- or over-exposure in relation to camera recommended settings. With snow for example, you may decide to ignore the warning and shoot at +1.5 stops over metered value for a white (instead of gray) Christmas scene. At approximately the same spot, an indicator for over-exposure (HI) or under-exposure (LO) appears in all auto-exposure modes. (Choose a different f/stop or shutter speed to avoid incorrect exposure). The frame number is usually displayed at the far right of the viewfinder LCD panel. When an exposure correction has been dialed in, a +/- symbol appears as a reminder. The flash symbol LED (lightning bolt) is located on the right side of the LCD panel. It glows green when flash is suggested or necessary based on ambient light conditions. This symbol turns red when the flash is charged and ready; after the exposure, it blinks or goes out while the flash is recycling.

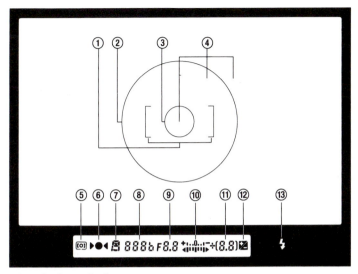

Viewfinder Display

1. Large AF Field
2. Center-weighted Metering Field
3. Spot Metering Field
4. Ground glass
5. Selected AF Field
6. Sharpness Indicator
7. Exposure Mode
8. Shutter Speed
9. Working Aperture
10. Electronic Analog Display
11. Frame Counter/Selected Vari-program/Compensation Factor
12. Compensation Mark
13. Flash Needed/Flash Ready

N90s/F90X: For Professionals, Hobbyists or Techno-Wizards?

Like the F4, the N90s/F90X offers limited use of non-AF Nikkor lenses in manual and aperture priority modes as well as unlimited use of the complete AF Nikkor series. A unique feature of the N90/F90 series is that these cameras (like the F4) are fully compatible with all the functions of the AF-I Nikkor lenses, with integral focus motor. Unlike the F4 and older Nikon cameras, they are also able to access the metering advantages offered by the D-type AF Nikkor lenses.

The N90s/F90X's fully electronic operation is particularly easy to use, much like the N8008s/F-801s. All important functions can be controlled without having to put the camera down. In comparison with the N70/F70 and the F4 with its Multi-function Back, the N90s/F90X together with the Multi-function Back MF-26 offers the most photographically useful functions to date. Less important are the N90s/F90X subject-specific Vari-Programs, at least from an experienced photographer's point of view. In contrast, the N90s/F90X's many flash modes are of great importance to all levels of photographers. As with every fully electronic camera, however, one should not expect the N90s/F90X to be as rugged as a good manual camera such as the FM2N. This concern is not unfounded. Static, persistent humidity, salt water mist, etc. can lead to the occasional disappointment.

For the advanced amateur, the N90s/F90X is probably the "dream Nikon" with which he or she will be better served than with an F4. For the pro, it is the ideal complement to the F4 since the new AF-I lenses and the additional potential offered by the Data Link System can be used with the N90s/F90X. If one recognizes the possibilities of the Data Link for remote display, remote control and automatic storage of exposure data, this is the most versatile and powerful Nikon camera to date: for documentation in research, development, and science. As the computer becomes more and more a necessary tool for the photographer, the N90s/F90X can be profitably used as a data communication device in photographic training.

A low camera angle produced this interesting juxtaposition of technology and nature. The satellite station antenna seems to be growing out of the grassy field. ⇨

Operating the N90s/F90X

Power Supply

The battery must deliver power for the film transport, the shutter, cocking the reflex mirror springs, cocking the automatic diaphragm spring, as well as for metering and the autofocus drive motor. It is logical that with such a camera, nothing works without batteries. Instead of the expensive, short-lived button cells, the N90s/F90X uses inexpensive AA cells which are available worldwide.

Alkaline cells: The more expensive 6v lithium sealed cell used by some cameras lasts longer than 4 fresh AA alkalines but costs about 2.5 times as much. In addition, it is not available everywhere. The lithium cell does have some advantages, however. It is smaller, lighter, has a longer life, and loses very little energy during prolonged storage prior to use (about a 10% loss in 10 years). More importantly, it will power far more rolls of film especially at low temperatures. On the other hand, AA cells are much cheaper, universally available and today, most are mercury-free (make sure when you buy) so they can be tossed out safely with other household garbage.

Carbon-Zinc batteries: Not recommended, these are inexpensive, have less power, a short shelf life and are useless at low temperatures.

NiCd batteries: Only fully charged nickel-cadmium batteries should be used. Since NiCds discharge internally more rapidly than alkaline batteries, they will power fewer rolls of film in mild temperatures. At sub-freezing however, they will last almost twice as long as alkalines (though not as long as lithium!) Modern NiCds can be recharged up to 1,000 times with a good charger and are therefore, very economical and environmentally preferred. A charger with a discharge device should be used, especially with sporadic use of the camera. Damaged NiCds should be properly disposed.

Battery Drain

According to Nikon specifications, a brand new set of alkaline AA batteries lasts for about 50 rolls of 36 exposure film and for about 9 rolls at 14°F (-10°C). With carbon-zinc batteries, only a few rolls will be powered; at lower temperatures, these batteries are practically useless. With NiCds, you get about 40 rolls at 68°F (20°C) and 16 rolls at 14°F (-10°C).

Add the MB-10 with two CR123A lithiums and this increases to 90 rolls and 25 rolls at the two temperatures mentioned. In practical tests (normal shooting) we found these estimates too high as with every brand of camera. Depending on the situation, and the use of autofocus, fast film advance, etc., we would cut the estimates in half.

The biggest enemy of batteries is low temperatures. Here only fresh and warm alkaline batteries or freshly charged NiCd batteries help, unless you have an MB-10 with lithiums. Otherwise, the use of the DB-6 is necessary.

Battery Testing

The working voltage of the camera is 6 volts. As long as there is enough power for the motors, there is always plenty left for exposure and focus readings. Poorly exposed or out-of-focus pictures, as a result of battery failure, are therefore impossible. (Tests indicate that the camera quits when the voltage drops to 5.4 v.) With new batteries, auto-shutoff of the LCD panel is in 8 seconds. With batteries that are just about dead, the panel display shuts off in 2 seconds. If the indicator turns off faster or starts blinking, you should try a new set of batteries. The N90s/F90X also has a battery condition indicator. If the battery symbol is no longer complete, you know it is best to keep a new set of batteries ready.

Battery Tips

Always keep a set of fresh batteries in reserve. In winter time, keep the spare batteries warm in a pocket. If you do not expect to use your camera for a long period, remove the batteries to prevent them from leaking in the camera. The new lithium AA batteries are not recommended by Nikon. Indeed, in our editor's tests, the N90s/F90X occasionally produced error warnings when these were used.

Film Handling

Obviously, a camera without film is as good as no camera at all. While the following may seem rudimentary, it is extremely important and should be reviewed.

Loading
Insert the film cassette from the bottom into the film compartment and ensure that the rewind prongs engage the cassette spool. Now, hold the cassette in the camera with you left thumb and gently pull the film out to the red mark with your right hand. Make sure that the teeth of the film sprocket line up with the perforations in the film. Close the camera back, press the shutter release button once, and the film will automatically be transported to frame number 1.

Possible errors: Trouble can only occur if the film was pulled out too far (or not far enough) during loading. Judging from the number of rolls of film we have loaded into the N90s/F90X, we can safely state that 1/16th inch more or less makes no difference. If you are not sure that the film was loaded correctly, simply look at the film counter on the LCD panel. The film transport is electronically checked and only actual film movement is counted. If the film is not properly inserted, has jammed, or is torn, the LCD panel will show a blinking film transport symbol. With the N90/F90 only, you will also hear a beeping sound.

Rewinding
If the end of the film has been reached, you will see the word "END" on the LCD panel and the camera will not fire. When the two buttons with a red film cassette symbol are pressed simultaneously, the rewind motor is activated and the film winds back into the cassette (the counter counts backwards). When the film end is reached, the counter on the LCD panel indicates empty ("E") and the rewind motor switches off.

The N90s/F90X rewinds the film completely into the cassette, including the leader. Some of us find that this feature has more advantages than disadvantages. For example, one can never confuse exposed film with unexposed film, even in moments of high pressure. Additionally, film that is completely rewound cannot be pulled out rapidly at the processing lab. A film end that sticks out

may be helpful for a darkroom technician, but pulling the film out of the cassette can cause scratches, and dust-attracting electrostatic charges. With high speed films from ISO 1000 and faster, light could enter through the slit in the cassette of a completely rewound film and slightly fog the first few frames. You should tape the slit shut with black tape right after taking the cassette out of the camera or wrap the whole cassette in tin foil. Both methods work well with high ISO film. By the way, several companies sell gadgets that can retrieve the film leader out of the cassette, should you wish to reload a partially exposed roll. These are usually available in any camera store.

If you want film rewind to stop with the leader out, keep an eye on the film counter as it is winding down. When it reaches 1, pop the back open. If your style of film handling dictates that the leader must remain outside of the cassette, you can have your camera reprogrammed by an authorized Nikon Service center so that film rewind stops at the leader each time.

If you want to reload a partially exposed roll of film, try this. With the lens cap on (and eyepiece covered) set for Manual at f/16 and 1/8000 second; press the shutter release. After you reach the frame number that was set before the roll was unloaded, click off a few extra frames to avoid any possible overlap of images.

Setting the Film Speed
Like most camera manufacturers, Nikon does not indicate old ASA or DIN values. These have been switched to ISO values (denoting International Standards Organization).

Manual adjustment: Hold the ISO button down and you can set the film speed from ISO 6 to ISO 6400 by turning the Command Dial. If you want to under- or overexpose a whole roll of film by deliberately changing the film speed, you should set the speed manually. Also, sometimes the film speed indicated by the manufacturer is not right for you and a manual film speed setting is necessary. If you attempt to correct only using the camera's exposure system, you could get confused if you also have to correct with respect to the subject. When loading another film type, remember to set the correct ISO or return to the DX symbol.

Automatic DX: Turn the Command Dial until the DX symbol

appears in the LCD. The ISO of DX-coded films (those cassettes with a checkerboard pattern) will automatically be recognized. Most film cassettes are imprinted with coded information that can be read by machines. By alternatively reading blank metal (conductive) and a printed surface (non-conductive), the camera picks up the code with electrical contacts and transmits this film speed code directly into the electronic exposure system.

If an uncoded cartridge is loaded, the camera blocks the release buttons and shows a blinking DX, ERR and ISO on the LCD panel. Wrong exposures are therefore impossible; you simply have to set the film speed manually.

If you take film out of a refrigerator and load it into your camera, the condensation on the outside of the cassette can confuse the DX contacts. (It can also damage the film and camera, thus, we do no t recommend using refrigerated film until it reaches room temperature!) The DX system can also be confused if you touch the cassette with sweaty or dirty hands. In the worst of all cases, the DX system will read the cartridge incorrectly and set a wrong film speed without warning. This is why you should double-check the ISO setting at the start of every roll by pressing the ISO button.

Motorized Film Transport

With a built-in motor drive, you never have to remove the camera from your eye to advance the film. When shooting a wedding party leaving a church, a soccer game, children playing, etc. you can keep aiming at the subject, increasing the number of good pictures. Selecting "S," "L," or "H" mode depends on the subject. The more hectic the situation, the more reason to switch to continuous film transport mode.

Motorized film transport is also of great help for copy work or close-ups with a tripod. Manually advancing film would constantly move the carefully positioned camera out of place. In order to keep camera shake to a minimum, you should work with a remote release or allow the self-timer to trip the shutter after vibrations have subsided. The best remotely triggered exposures are really only possible with motorized film transport.

Some photographers who are concerned with shooting unobtrusively have misgivings about winders and motor drives. The

motor drive is just too noisy to permit undetected shooting. If this is a problem, you can buy accessories which will muffle the camera, although the N90s/F90X is relatively quiet when compared to some older models.

Camera Trouble

When the N90s/F90X will not function, there are several possible causes. You may need new batteries, or may be using an unsuitable lens. Mistakes like these can happen to anyone in hectic situations. In these cases, the N90s/F90X diagnoses and indicates the problem for you. The situation is different if the photographer gets confused with the multitude of camera functions or if the camera itself stops working due to overload.

Reset button: If you cannot figure out what is wrong, the best solution may be the reset button. To reset the N90s/F90X, simultaneously press both of the green reset buttons. The camera will return to its basic functions. (The reset buttons of the N90s/F90X can also be used to activate or deactivate the functions of Data Link. For more information on the Data Link, please refer to that Section).

Overload warning: The following symptoms may result from system overload: the shutter does not release, the LCD panel blinks meaninglessly, the mode cannot be changed, the main power switch does not operate, or the mirror does not spring back.

Causes: Several causes are possible, among them slightly jammed film and electrostatic charges. Problems caused by incompatible lenses or bad batteries are not considered overloads.

Remedy: Switch the camera off and remove the batteries for several minutes. The overloaded micro-computer will discharge itself and should become operational again.

If this type of problem happens frequently, take the camera to your nearest Nikon dealer for analysis by a Nikon service center. Make sure you are able to provide proof of purchase and/or other warranty information if your camera is still covered by the manufacturer's warranty.

Autofocus: How Does it Work?

The AF system of the N90s/F90X, simply stated, consists of 4 building blocks. The first is the ROM microchip in the lens, which transmits vital information such as brightness, selected focal length, actual aperture, and distance setting via the contacts inside the bayonet mount.

Inside the camera is the AF module (CAM246). This semi-conductor CCD (Charge-Coupled Device) array consists of 172 horizontal and 74 vertical CCDs in a cross formation. Two closely timed sets of information from these CCDs are interpreted by an IC (Integrated Circuit) and the result is passed on to the camera's CPU. The computer then calculates the two successive distance values and determines (with moving objects) the estimated distance at the time of the shutter release. This estimated distance is then calculated with the lens data to establish an electronic command for the autofocus motor. The AF motor IC then passes this information to the motor itself in the form of specific number of revolutions, either forward or backward.

The motor's rotation is then reported back to the AF-IC. At the same time, the motor causes the focus system of the lens to turn via a mechanical hook-up and clutch. When the lens focus setting is complete, the CPU checks the focus once more at the AF-IC and, if confirmed, passes the information on to the viewfinder LCD where the "in-focus" symbol will appear. Ideally, all these operations from the double distance reading to the focusing of the lens and the viewfinder indication should take less than 1/10 second.

If the camera's CPU, after checking with the AF-IC, still detects an out-of-focus setting, the process will be repeated by driving the lens focus from close-up to infinity. If again no focus setting is achieved, the CPU passes this information on to the viewfinder display which will blink, indicating that a sharp picture is not possible.

Defining Sharpness

An image is said to be in focus if every point of an object at that same distance is reproduced as a sharp point on the film plane. If the distance is not properly set, then the points of an object do not have a sharp outline any longer, they melt together with other points surrounding them.

Out-of-focus images are the result of one of two things: distance set too close or distance set too far. If, for instance, an object is 5 feet away and the lens is set at 2 feet, the light rays will form a sharp image in front of the film plane. To obtain sharpness, the lens should be turned towards the 5 feet setting, clockwise with Nikon lenses, until the light rays exactly form a sharp image on the film plane. If the lens is set to infinity instead of 5 feet, the light rays of an object point will produce a sharp image behind the film plane. This means that the focus ring on the Nikon lens would have to be turned counter-clockwise.

The task: When you switch to autofocus, the system will automatically read and evaluate the blurring of object points. First, the appropriate focusing movement has to be recognized, and second, the camera's CPU must calculate the necessary lens adjustment. To do this, the sensor group (CCD chip, plus evaluating IC), reads the expanding blurring of object point caused by incorrect distance setting at the film plane. To be really accurate, the reading is not done on the film plane, but instead, on a part of the picture that is redirected to the CCD via a secondary mirror.

Accurate focusing: When the lens is focused at the proper distance, the light rays of the sharp object point are projected onto the AF sensor such that two neighboring reading fields receive practically all the light; field "A" from one half and field "B" the other half of the lens. The electronic focus IC evaluation is programmed in such a way that it will compare the curve of all "A" points with that of all "B" points. If the two curves overlap (the curves are "in phase" in electronic language) then the focus IC reports "picture in focus" to the central computer.

Out-of-focus images: When the lens is focused too close and the sharp image is in front of the film plane, the AF sensor will not only be illuminated by one set of blurred images, but by several. The result is that the curves of the "A" fields and "B" fields have separate peaks. The same thing happens if the lens is focused too far. Since the curve displacements for lens settings that are "too close" and "too far" are opposite of each other, the focus IC can determine what the focus correction should be, based on the phase shift between the two curves. These findings are transmitted to the

camera's central computer. This data combined with other lens information is used to calculate the proper lens setting.

Taking Pictures in AF Mode

Select the AF mode and the desired focus detection area size, aim at your subject and press the shutter release half-way. When the in-focus symbol (lit dot between the two arrows) appears in the viewfinder, you can fully depress the trigger and be guaranteed a sharp picture.

Keep in mind that every form of automation is only as good as its application. Unlike manual focusing, which is instinctive for the experienced photographer, autofocus demands a deliberate decision. Only when the photographer knows exactly which area of the subject should be in focus can he or she aim precisely. After that, however, the autofocus mechanism quickly takes care of the rest.

Single Servo Autofocus

By setting the camera to the "S" mode, you've activated the single servo autofocus. In this mode, the camera will not fire unless the subject is in-focus! To activate the system, turn on the camera and partially depress the shutter release button. The camera's autofocus system should jump alive with the whirl of the motor as it focuses the lens. With the subject centered in the viewfinder, the camera should instantly lock onto it. (There are conditions in which the AF system will not function which will be covered shortly.) If this is the photograph desired, pressing the shutter release all the way down will capture the in-focus subject on film.

What if the composition created by placing the subject dead center is not desired? With the autofocus system locked on the subject and while still depressing the shutter release, the subject can be reframed by redirecting the camera. This must be done with care, changing the distance between the camera and subject will alter the focus. Depressing the shutter release button completely will fire the camera. If the camera is in the "S" film advance mode, the camera will take just one frame. Be forewarned that each time you let your finger up to fire again, the camera will refocus. If the subject is not in the center of the brackets, the camera

will refocus on whatever is there. This could cost you precious photographs.

Continuous Servo Autofocus
Switching the autofocus lever to "C", engages the Continuous Servo Autofocus mode. In this mode, the autofocus system will continually search for a subject to focus on as long as the shutter release is lightly depressed. It will lock on a subject, but if the camera is moved or the subject should move, the camera will refocus. The difference between this and the "S" mode, "S" will not refocus unless the shutter release is released and then depressed again. And in this mode, the camera will fire whether the subject is in-focus or not.

The "C" autofocus mode can be used with any of the film advance modes, but it works best for shooting moving subjects in one of the continuous film advance modes. In "C" autofocus mode, you want to be able to take advantage of the fast response time of the camera.

Which mode to select when: The general rule of thumb is use the "S" mode for stationary subjects and the "C" for moving subjects. Photographing subjects such as scenics, portraits or any other none or slow moving subject are great for "S". The insurance provided by "S" mode of not firing unless the subject is sharp is also nice. But what if your portrait subject is a small child? "S" might not be the right choice, because they usually don't hold still.

In this case or when photographing any subjects which constantly moves, such as sports or wildlife, "C" is the best option. In fact, Continuous Servo AF mode will often be the most successful way to capture otherwise difficult photographic subjects. Remember, the "C" mode allows you to achieve focus lock by using the AF-L button.

If the camera is in either the "L" or "H" film advance mode, the camera will fire multiple frames until the shutter release button is no longer depressed. As long as the subject stays in the AF brackets, the camera will take in-focus photographs frame after frame. If you focus on the subject and then recompose the photograph by moving the subject out of the AF brackets, all shots after the first one will be out of focus. The reason is after the first image, the system will refocus. With the subject no longer in the AF

brackets, the camera will focus on something else. When recomposing, beware that all you will get is one in-focus frame from this film advance mode.

Autofocus Lock

In "S" AF mode, you can get a sharp image even if your subject is not in the AF detection field. First, aim the camera so that the subject is at the center of the frame; then partially depress the shutter release button until the viewfinder display shows the in-focus symbol. The focus distance will remain unchanged as long as you maintain pressure on the trigger. You can now recompose, with the subject anywhere in the frame, instead of dead center.

If you decide not to take the picture after all and want to focus on another subject, simply release the shutter button. The stored distance setting will be automatically cleared. Depressing the shutter release again restarts the whole process.

In AF mode "C": If, after aiming and focusing in Continuous Servo AF mode, you press the AF-lock button, the focus setting will remain constant. As long as you keep the AF-L button depressed, you can take as many pictures as you like with this stored distance setting.

In AF mode "S": In Single Servo AF mode, stored focus information is cancelled after each exposure and the AF system starts to refocus. However, after focusing on a specific subject detail, you can release the shutter button and press the AF-L button. This tactic locks focus so you can take as many pictures as you like with focus locked at the original distance.

Long-term AF storage: If you wish to take several pictures of a subject at a constant distance but at longer time intervals, then manual focus is a better alternative. After focusing in AF mode "S," release the shutter button and switch to "M" (manual focus). Now, the selected focus setting remains constant until you decide to alter it by rotating the focus ring on the lens.

Autofocus Field Sizes

Autofocusing of the N90s/F90X is possible with either of two different-sized AF detection areas. There is no rule as to which one

Use the Hyperfocal Vari-Program when extensive depth of field is desired. You can use Autofocus Lock to keep the subject in the foreground sharp and then recompose the picture to include the background scenery.

is better. It depends on the specific subject and the methods of the photographer.

Narrow area: In our experience, selecting the smaller focus detection field is safer when the subject has a complicated structure. If the focal point of a large, deep subject should be at a specific distance, then a selected edge can be accurately pin-pointed with spot autofocus. With the wide field, other subject areas will be included and it is questionable where the effective focus setting will end up. Normally, spot autofocusing takes a bit longer, a fact that could be very annoying in hectic situations. Use it for subjects which benefit from a "decisive point of focus" such as portraits, landscapes, and architectural pictures. Set focus for the desired point (an eye, perhaps) and recompose with slight pressure on the trigger to hold focus.

Wide area: The advantage of the wider AF field is that there is a good chance that an edge of almost any subject will be selected

for the camera to focus on. The wide AF field is therefore ideal for all types of action shots, especially when a small subject does not remain dead center in the viewfinder for an entire series of frames. Always bear in mind that there is the chance that a certain critical subject detail may not be the one which is in focus.

Focus Priority
In the Single Servo AF mode, the N90s/F90X always uses focus priority. In other words automatic focusing must precede the shutter release. Until focus is achieved, the picture cannot be taken. It is the other way around with the Continuous Servo mode. Here the shutter release takes precedence over focusing, allowing you to shoot a long sequence of frames. Some will be unsharp, but most should be in focus thanks to the camera's high-speed tracking ability.

Focus Anticipation
Both AF modes "S" and "C" use multiple lightning-fast measurements, one after the other, in order to predict the probable distance of a moving object at the instant of exposure. In other words, the system sets focus for the likely position of the subject at the moment the shutter is released. This AF control works with an anticipated focus setting or calculation, often called "predictive autofocus".

Focus Tracking: If, in Continuous Servo mode, the shutter release button is only slightly depressed, the N90s/F90X's autofocus continuously corrects focus. That is, after each focus adjustment, it immediately takes the next two readings and refocuses if necessary. Therefore, with moving subjects, focus is continuously readjusted. Nikon's terminology for this process is Focus Tracking.

Autofocus with Flash Assistance
If there is not enough light, neither autofocus nor the human eye is capable of achieving focus. In this case, the use of a Nikon autofocus Speedlight SB-20, SB-22, SB-23, SB-24 or SB-25/26 is helpful.

In total darkness: In addition to the regular flash possibilities, these flash units contain a special near-infrared AF illuminator. In low

During a fast-paced carnival or parade, use the Sport Vari-Program and "Continuous" autofocus to catch the action.

light conditions, set the N90s/F90X to AF mode "S" and depress the shutter release button. The Speedlight will project a red pattern as a target for the AF sensor. The visible portion of the near-infrared beam is bright enough to be seen up to about 20 feet. If you take a picture now, sharp focus is guaranteed. After focusing with the pulsing infrared beam, you can also store the distance. Gently press down on the shutter release button or the AF-L switch (or access Manual focus) and then turn the flash off. Now you can take available light pictures at the proper focus setting.

With low-contrast subjects: The emitted beam permits focusing on low-contrast subjects (such as a blank wall) by giving the N90s/F90X a more reliable target than a monochromatic surface. This works especially well in moderate light which does not overpower the near-infrared pattern.

Autofocus Requirements

The autofocus system of the N90s/F90X reads distance indirectly. That means that the subject is scanned from the image projected

by the camera lens; from this, the camera's computer will calculate the necessary movement of the lens. After all, the automatic focusing depends on the reading and evaluation of picture contrast. That in turn, means that the subject has to have some contrast and the projected image from the camera's lens cannot be too dark.

Subjects and situations where AF does not work do not necessarily detract from the many advantages inherent to autofocus photography. After all, even a human can only see objects if they are bright enough and if the outlines or details are clearly defined.

Lens selection: Slow lenses (with maximum aperture opening of f/8 or smaller, or an f/number higher than f/8) are useless for AF photography. The AF system needs a relatively bright image to recognize sharpness. With small apertures, the edges of the light transmission are cut off and the light beam is too narrow. For the N90s/F90X, the lens must be f/5.6 or faster.

Additionally, autofocus is not always successful with very short focal lengths. The AF system can be confused due to the extensive depth of field of extreme wide angle lenses. Even in these cases, there is an optimum focus distance, but the AF system occasionally has difficulty finding it. This is similar to a photographer who, if he is not sure, uses the distance scale rather than trusting his eyes.

Object brightness: The autofocusing system has problems with subjects darker than EV 1 (approximately candlelight). At this light level, even manual focusing is almost impossible. Use a Nikon Speedlight with an AF assist beam projector.

Subject contrast: Another difficult situation arises with low-contrast subjects. Typically, the AF mechanism of the lens will focus from close-up to infinity, and then the focus confirmation symbol will appear in the viewfinder display.

Subject structure: When the detail of an otherwise contrasty subject is too small or fine, some autofocus systems can fail. For instance, try focusing on the small black type of a newspaper. In contrast to the old AF sensors, the cross field sensor of the N90s/F90X does not differentiate between the horizontal or vertical orientation of a line. The AF system of the N90s/F90X should

achieve focus whether the pattern is vertical, on an angle, or horizontal.

Strong backlight: Extremely backlit situations or highly reflective objects (such as chrome trim) can create difficulty for any autofocus system. The extreme brightness actually lowers the contrast to a level where AF is no longer possible. These situations are rare.

Difficult to define subjects: Here we are talking about various subjects at different distances. An example is two children standing beside each other, but with one closer to the camera. The face of the child in front is in one section of the wide focus detection field and the second is in another section. Which child should the camera focus on? Practical experience indicates that it normally selects the nearest or brightest subject. Sometimes this can be annoying, as in shooting through a wire fence, wanting the background scene to be in focus. In these cases you should switch to Spot AF; then, target your subject, lock the focus, recompose and shoot the desired composition. If this still does not work, you can always resort to manual focusing.

Filters and creative lens attachments: There are 3 general situations in which lens attachments can make it difficult or impossible for the AF system to work: 1) You can take too much light away and thereby lower the light transmission of your lens (e.g. color filters, graduated filters, vignettes, etc.). There is nothing to worry about with UV or skylight filters. 2) You can reduce the contrast too much (e.g. soft focus or fog filters). 3) You can polarize the light and confuse the AF sensor that is sensitive to linearly polarized light. Circular polarizers (usually designated CIR) should always be used with autofocus cameras, instead of linear polarizers.

Using Manual Focus

With unsuitable subjects or slow lenses that cannot be used with autofocus, you must focus by eye. In the manual focus mode "M", you have to focus in the conventional way by turning the focusing ring of the lens by hand. This mode is also required with non-AF lenses.

With lenses of f/5.6 or wider maximum aperture, the focus assist system comes to your aid. The focus indicator in the viewfinder displays which way the lens has to be turned, and when focus has been reached by displaying arrows or a circle in the viewfinder.

Exposure Metering Modes

The N90s/F90X has three distinct exposure metering patterns: center-weighted, spot, and Matrix metering. These include an option for every situation. Additionally, if circumstances warrant, the N90s/F90X's exposure can be manually set, using your judgment or an accessory light meter. To select the metering mode, hold down the metering system button and turn the Command Dial until reaching the desired symbol on the LCD panel.

Integrated center-weighted metering with 75% of reading from the center of the image.

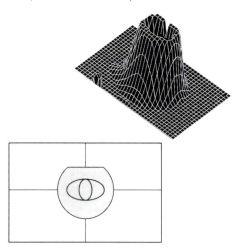

Center-weighted Metering

In this mode, the brightness of a subject or scene is measured as follows: 75% of the emphasis is placed on the area within the large circle in the center and 25% on the rest of the scene. If the main subject is in the center, the result is normally a well exposed picture unless the subject is brighter or darker than a mid-tone.

This method is very useful if one has enough time to consider subject reflectance and compensate with over- or underexposure

from the meter's suggestion. This is a familiar metering pattern for those previously using conventional cameras, and included by Nikon for those who were trained in metering using this method. With center-weighted metering, a photographer who uses several Nikon cameras interchangeably (e.g. F3 or FM-2 and an N90s/F90X), can use the same metering method on all cameras, without constantly having to rethink his or her actions.

Spot metering concentrates the reading on only 1% of the total picture area

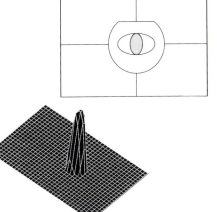

Spot Metering

Here, the subject's brightness is measured in only the very center (1%) of the picture area. This permits extremely accurate measuring of reflectance in a tiny area.

Since the degree of reflection from the specific area is very important, only experienced photographers will get good results. A lack of experience will lead to exposure errors when using the spot metering method in a point-and-shoot mode. Even the professional should only use spot metering if the situation allows enough time to select an area which should be reproduced as a mid-tone in the photo.

Advanced Matrix Metering

With Matrix metering, the brightness and relative contrast of a scene is measured in 8 separate areas of the picture. With the

N90s/F90X as well as with other contemporary Nikon AF cameras, the Matrix system always works together with an automatic exposure correction (see below).

The 8-segment Matrix reading can be made with all AF Nikkor lenses in all exposure modes: any Program mode, shutter priority AE, aperture priority AE, with or without autoexposure lock (AE-L), or in Manual mode.

The basis of the automatic Matrix metering system is an eight-segment reading. The reading is averaged over five segments and taken as exact in the other three.

Three-Dimensional Matrix exposure: This is only possible with the latest D-type AF Nikkor lenses which contain a chip that reports the subject distance to the Matrix metering system of the N90/F90 Series cameras. When one of these lenses is attached, the camera automatically enters 3D mode. The N90s/F90X uses all 8 segments of the sensor but weights the information in relation to the distance setting. In addition, the N90s/F90X's Matrix metering system recognizes a primary subject that is off-center if you have locked focus and recomposed the image. At this point, the center of the image area is out of focus, so the system recognizes that the primary subject is now located elsewhere in the frame. Consequently, the N90s/F90X uses the outer segments to set the exposure which is more likely to render the subject accurately.

Matrix operated exposure correction: The camera's computer calculates an automatic exposure correction based on the total picture brightness and the brightness difference of the 8 segments

(contrast). As a result, you do not always need to make any calculations yourself, nor do you always have to make any adjustments on the camera. For example, the Advanced Matrix system recognizes an ultra bright scene, such as snow, and automatically increases exposure to render it closer to white than gray.

Matrix Metering Limitations
There are several situations which cause problems for even 3D Matrix metering.

Very small or very finely textured subjects: If the main subject does not appear as a solid area in the frame (such as thin branches or a wire fence) the camera may not recognize it as a back-lit scene and will not make the appropriate exposure correction.

White on white*:* The N90s/F90X's exposure correction calculation is obviously dependent on the film sensitivity and on how much of the picture area is white. Matrix will often expose a sunlit snowscape properly, but on a cloudy day it may underexpose (resulting in gray snow).

Black on black: The N90s/F90X's proper exposure calculation obviously depends on how much of the picture area is black. Scenes such as a chimney sweep in a coal cellar will result in an exposure error with the 3D Matrix system producing overexposure rendering black as dark gray.

Back-lighting with slow film speeds under overcast skies: Matrix metering does not always add enough exposure so the picture may consist of a nicely exposed sky but an underexposed landscape.

Which Metering Method to Choose
There are some shooting situations where one does not have time for careful metering with the spot or center-weighted pattern. In other situations, one may be uncertain as to the amount of exposure compensation required. Exposure bracketing (varying exposure from frame to frame) is a relatively tedious process and may not be feasible when the light is changing rapidly, or the subject is in motion. Advanced Matrix metering then becomes a suitable alternative even for the professional. In approximately 80% of the

Because a camera's meter is calibrated to expose for middle or 18% gray, taking a light reading off a gray card placed in the scene can produce a more accurate exposure.

cases, the results are good to very good with slide film. With negative film, where corrections can be made at the time of printing, Advanced Matrix metering provides suitable negatives well over 90% of the time.

If you want better results than you believe Matrix metering will provide, switch to the spot or center-weighted metering pattern, preferably in manual ("M") mode. In these cases, taking a meter reading from a Kodak® Gray Card, or some mid-toned alternative (such as green grass or tanned skin) which is in the same light as the subject is recommended. Set the suitable f/stop and shutter speed, then recompose. Ignore the warning provided by the analog scale in the viewfinder, and your subject should be properly exposed. This is really only a starting point, but expert metering techniques are beyond the scope of this guide.

Autoexposure Lock

The purpose of autoexposure lock (AE-L) is to give the photographer greater control over exposure settings when using the autoexposure modes. To lock in an exposure reading, meter on an area by partially depressing the shutter release and then slide the AE-L lever. The image in the viewfinder can then be recomposed without changing the exposure settings.

Areas of application: This feature is useful for any situation involving exceptionally light or dark subjects. For example, when photographing a setting sun, even matrix metering can produce an underexposed picture if a large portion of the viewfinder contains bright sky. To correct for this, fill the viewfinder with a greater portion of darker foreground, use AE-L to hold the meter reading and then recompose the image. Photographers accustomed to using an autoexposure mode may find it quicker to use autoexposure lock than to change exposure settings in Manual mode.

Exposure Compensation

By pressing down on the +/- button and turning the Command Dial, you can bias the meter reading from -5 EV to +5 EV in 1/3 stops in any mode. It makes sense to input compensation if you know the amount that will expose your subject properly. That may be as much as +2 stops for snow, or -2 stops for a black truck. Experience and study will help develop your skills in this regard.

Areas of application: Manually input exposure correction is particularly useful with all-black or all-white subjects. In combination with center-weighted or spot metering, the experienced photographer will be rewarded with outstanding results.

Remember that the selected film speed interacts with the metering and control of the N90s/F90X electronics. With Matrix or center-weighted metering, using a film of ISO 100 and a lens with maximum aperture f/1.4, you have a range from a low EV 1 (corresponds to f/1.4 at 4 seconds) to an extremely bright EV 21 (f/22 at 1/4000 second). With spot metering, the control range with ISO 100 only extends from EV 3 to EV 21 (less useful in low light). Switch to a higher ISO film, and the metering system will operate in even lower light. With slower film (such as ISO 25) it will operate in even brighter conditions.

Exposure Modes

Program Autoexposure Mode

The principle of the fully automated program mode is simple: the camera automatically sets the shutter speed and the f/stop setting according to the film speed and the brightness of the scene. With the addition of autofocus, all that remains for the photographer to do is select a scene and compose the image in the viewfinder. The aperture and shutter speed combination selected by the camera depends on several factors including, the situation at hand and the lens being used. The chosen shutter speed is slower for wide angle lenses and faster for telephoto lenses, provided it is at least equal to the inverse of the focal length. For example, 1/60 second with a Micro Nikkor AF 60mm f/2.8D. Except in low light, the computer will only select an aperture that satisfies this condition. Blur, due to camera shake, is therefore avoided, at least in relatively bright conditions.

Are photographs taken with the Program mode merely "snapshots"? Not necessarily. Simply because some of the mechanical functions (like fiddling with f/stops and shutter speeds) have been automated, does not reduce the potential impact of the final image. For capturing a decisive instant in sports, a baby's smile which will not recur, or for quick, candid portraits, we're not too proud to switch to a Program mode.

Procedure: First, let's access the standard Program. Begin by setting the lens to its minimum aperture (the highest f/number on the ring); lock it in with the small tab provided. Press the MODE button. While holding it down, turn the Command Dial until "P" is displayed in the LCD panel. Next, select the focusing mode (AF or Manual), the size of the AF detection field, and the exposure metering pattern. Now look through the viewfinder and activate the systems by lightly pressing down on the shutter button. In the viewfinder display, you will find the symbol "P" designating "Program". To its right, you will see the computer selected shutter speed and f/stop. Once your subject is in focus, you have nothing more to worry about and can release the shutter any time.

Concentrate on the subject rather than camera operation, by using Program mode and Matrix metering.

Troubleshooting

If a Nikkor AI or AI-S lens (without a built-in ROM chip) is used, the program symbol in the viewfinder will blink, and the camera will automatically select a shutter speed to prevent gross exposure error. Please note that no f/stop value is shown in the viewfinder when non-AF lenses are used. There are a variety of other indicators that will appear in the LCD if there is a problem.

"EE" You forgot to set the lens to its smallest aperture (largest f/number).

"HI" Your scene is so bright that the exposure range of the N90s/F90X is exceeded, and you will have an overexposed frame. Select a smaller aperture or longer shutter speed. If not possible, use a neutral density filter (or a polarizer) to block some of the light.

"LO" Danger of underexposure is indicated. Use flash or higher ISO film if a wider aperture/longer shutter speed is not possible.

Audible beep (N90/F90 only): Danger of blurring due to camera movement. The shutter speed is too long to hand hold the camera

Page 65:
To avoid moving around too much and distracting your subject, use a zoom lens. You can change the framing of an image without changing positions.

Page 66:
Rather than just document these Native American drawings, the photographer dramatized them by using a wide angle lens and shooting upward.

Page 67:
Reflections in water often create an interesting combination of shape and color. To increase contrast and color, the original slide was duplicated onto standard transparency film. Photo: Wolf Huber

Page 68:
The same exposure should result using any of the N90s/F90X's metering modes. However, spot metering (top) or center-weighted metering (middle) may require the photographer to evaluate tonal values within the scene. Matrix metering (bottom) will provide correct exposure without the photographer's attention in most situations.

Page 69:
Top: Manual exposure set for the background (f/8 at 1/250 second) was enhanced by using fill flash to illuminate the foreground. The result was a well-balanced picture.
Bottom: With an ISO 400 film and aperture priority AE in SLOW flash mode (f/5.6 at 1/15 second). Using slow sync flash produces a sharp exposure plus some motion blur as a result of the ambient light exposure.

Page 70:
By looking carefully at this picture, it can be determined that fill flash was used to enhance the lighting. The brilliant sparkle and clean colors found in this Halloween "still life" could not have been achieved without flash. Photo: Peter K. Burian

Page 71:
Top: In some situations, even 3D Matrix metering is not foolproof.
Bottom: For greater accuracy, the light gray cabin roof was spot metered, producing an exposure that was 3 stops brighter.

Page 72:
Let the water flow from horizon to foreground with the 20mm f/2.8 AF and give it life with a slow shutter speed of 4 seconds.

for a sharp picture. Since the system has selected the fastest shutter speed possible, rest the camera on a solid surface or tripod. As an alternative, switch to a higher ISO film, a shorter focal length, or use flash.

Program Mode Applications
For the experienced photographer, Program mode is useful whenever capturing the subject on film is more important than the exact f/stop or shutter speed. In addition, anyone who does not like to think in technical terms is also greatly assisted by this automation.

Recommended Lenses: In Program mode, the most useful lenses range from 28mm to 200mm. Considerably shorter or longer focal lengths are usually used for special subjects or scenes. In that case, switch to one of the subject specific Vari-Programs or another mode.

Recommended Films: Medium film speeds are recommended. The most commonly used transparency film speed is ISO 100 and for color negatives, ISO 200. Program mode is not generally used for subjects that require extremely slow or fast films, as one of the other modes is generally more useful.

Flexible Program Mode
The settings selected by the Program mode can be manually changed. Using the Command Dial, you can adjust the aperture/shutter speed combination *while maintaining the same exposure value.* You can therefore stay in Program, now called Flexible Program, while varying the depiction of motion and depth of field. If the shutter speed is too long or too short for your subject, or if the aperture is too large or small, simply shift to the desired combination. With the N90s/F90X, shutter speeds will shift in 1/3 steps for very precise control.

After taking the picture, the system reverts back to its selected f/stop/shutter speed combination. If you decide to shift again, follow the procedure above. Turning the Command Dial to the right chooses faster shutter speeds/wider apertures, such as 1/1000 second at f/4. Turning to the left selects slower speeds and smaller apertures, such as 1/500 second at f/5.6 and so on as long as you keep turning until all available options have been selected.

Program Automation

The metering system calculates the correct exposure value to achieve proper exposure given subject brightness and the film speed used. The light values are automatically converted into a correct combination of shutter speed and aperture according to a program curve. In other words, the Program mode automatically selects a suitable f/stop and shutter speed from a multitude of such combinations, as programmed by Nikon engineers.

The following exposure value/aperture/speed diagrams illustrate the N90s/F90X program curves. These curves indicate the aperture and shutter speed combinations at any given light value (brightness level). One exposure value "EV" is nothing more than a numerical measurement of one stop or one step. A low EV number denotes low light, and a higher number brighter light. The EV number of a specific exposure value always represents many equally effective aperture/speed combinations. In other words, you can get the same exposure with various combinations of aperture and shutter speed.

Standard Program Curve: The main attraction of the standard program mode is its ability to adapt the program curve to the maximum aperture and focal length of the lens being used. This is ideal with zoom lenses where the focal length covers a large range from wide angle to telephoto and where the effective aperture often changes as you zoom. Here are some practical examples.

Zoom lens set at 28mm f/3.5: With ISO 100 film, a scene lit with a 60 watt bulb has a brightness level equal to about EV 2. At EV 2, the Program will select f/2.8 or f/4 with an exposure time of approximately 3 seconds. If, however, the camera reads a light value of EV 12, (a day with dense clouds at ISO 100), the Program would select f/8 at 1/80 second. With EV 20 (a picture in noon sunshine with blue sky at ISO 100), a setting of f/22 at 1/2000 would be used.

Zoom lens set at 70mm f/4.5: In this case the program curve starts at EV 2 due to the smaller maximum aperture (f/4.5) and the exposure would be f/4 or f/5.6 at 3 seconds. At EV 12, the curve shows that the aperture will be close to f/5.6 at first, but with shorter focal lengths, the system would stop down to smaller aperture/longer

Multi-Program Curve

shutter speed. This moderate stopping down (with longer shutter speeds) continues to EV 16, where the curves for both focal lengths combine again.

Understanding the Curves: In order to understand these curves, you should keep in mind which conditions remain constant and which vary during any given shot. Nikon makes the confusing statement that "at ISO 100, the track of the curve does not depend on the film speed." What is really variable is the brightness of the scene and the film speed. If you already use a specific speed of film in the camera, the "decisions" made by the camera depend only on the scene brightness. Let's say the brightness is given and you are deciding which film speed to use. Simply slide along the curve to arrive at smaller apertures (larger f/numbers) and faster shutter speeds when selecting films with higher ISO numbers.

Limits of Program Curves
If we look at the standard Program curve, we notice the following:

from EV 11 (at f/4.5) towards lower values, the program only changes shutter speeds depending on lens speed and focal length. In other words, the aperture remains wide open and the exposure correction takes place only by lengthening the shutter speed (depending on film speed, up to 30 seconds). At extremely high light values of EV 20 (f/22 at 1/2000) to EV 22, the curve shows constant aperture and changes shutter speed to 1/8000 second. With lenses that have apertures as small as f/32, the curve would show f/32 at EV 23.

Photography with Subject-Specific Vari-Programs

This type of automation made its Nikon debut on the N90/F90. By selecting one of seven preset programs, the photographer has the right tools for a very specific job at his or her fingertips. In other words, the programmed automation sets a shutter speed/aperture combination considered the "best" for the subject type. *Note: Flexible Program mode is not available with any of the Vari-Programs.*

Procedure: While pressing the "PS" button (to the left of the pentaprism), turn the Command Dial to one of the seven programs. Watch the symbols in the LCD panel and stop when you reach the one you want.

Portrait Program "Po"
This mode sets the camera to produce an in-focus subject against a softly blurred (out of focus) background.

Recommended lens and exposure method: Autofocus lenses from 80mm to about 200mm with a maximum aperture of f/2.8 combined with Matrix metering is recommended. The "Po" program is not very useful with lenses of small maximum aperture such as f/5.6 —or with short focal lengths — because depth of field is excessive to blur the background. *Note: Like all the Vari-Programs this one can be used with flash.*

Performance test: During our tests, the "Portrait Program" always used an aperture of f/2.8 or slightly wider, regardless of the film speed (ISO 100 to 400) or the subject brightness.

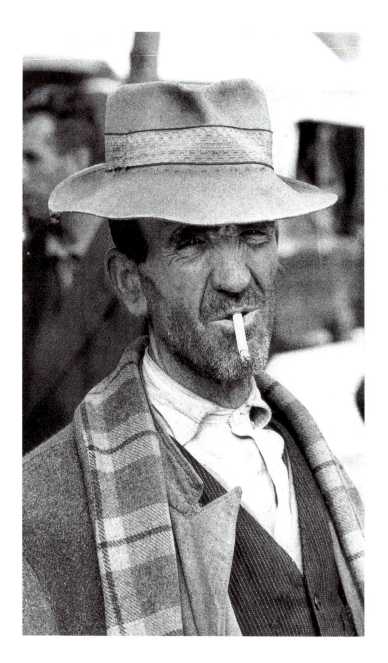

Verdict: This program takes the easy way out. After all, you do not always need the widest possible aperture with various camera/subject and subject/background distances. And while this program prevents disasters, in some cases, a pro could be up to one f/stop more accurate, thus, producing a more pleasing overall effect with a different aperture.

Portrait Program with Red-eye Reduction "rE"

In this mode, the desired effect is the same as above, but with a red-eye reduction feature: pre-flash with the SB-25 and an incandescent lamp with the SB-26. In both cases, this should help contract the subject's pupils, reducing the red-eye syndrome.

Recommended lens and exposure method: Same as with "Po" but shorter focal lengths reduce the risk of red-eye. Please note, however, that red-eye reduction is possible only when using the SB-25 or SB-26.

Performance test: The SB-25/26's reflector is situated relatively high above the lens axis and the light quality is relatively soft. Hence, even without this measure, you will rarely have a red-eye problem except in dark conditions and with longer focal lengths. With some experience, you'll soon determine when "rE" is required.

Verdict: The brighter pre-flashes of the SB-25 are more useful. In difficult conditions you can never totally eliminate this syndrome, but even slightly reduced red-eye is less objectionable.

Silhouette Program "SL"

The purpose of this mode is to automate the metering required to produce a dark foreground subject against a nicely exposed (bright) background.

↰ **Portrait mode was ideal for this situation; the camera chose exposure settings biased towards a large aperture to blur the background and the photographer was free to capture the subject's expression.**

A silhouette is created by underexposing a backlighted subject; there must be at least two stops difference between the subject and background. Although metering for this effect can be difficult, the camera's Silhouette program produces excellent results.

Recommended lens and exposure method: Any mid-range lens will work fine in this Program, in Matrix or center-weighted metering. We like to use a telephoto for distant scenes, for greater impact. As far as exposure goes, the background has to be at least two f/stops brighter than the subject. Once this condition is met, the system will expose for the bright background, rendering the foreground subject without detail. Do not use flash! The Silhouette Program permits long exposure times which, in turn, could result in blur due to camera shake. If possible, use a tripod.

Performance test: The Silhouette Program does indeed select an exposure which renders the subject dark especially when the background is much brighter (e.g. 4 stops). A pro would have to take meter readings with great care to obtain the same or better picture.

Verdict: Very useful, but only in specific conditions.

This high voltage tower confirms that the subject need not be a landscape to benefit from the extensive depth of field provided by the Landscape Vari-Program.

Hyperfocal Program "HF"

In order to obtain extensive depth of field (wide range of apparent sharp focus), this Program selects a small aperture opening (high f/stop number). The danger is blurring due to camera shake or subject movement, because of the longer shutter speeds required.

Recommended lens and exposure method: Autofocus lenses from 50mm down to 20mm using Matrix metering. Since the "HF" program may select exposure times too long for hand holding the camera, a tripod must be used in certain instances.

Performance test: In our tests, the "Hyperfocal" Program always selected f/11 as long as the film speed (ISO 100 to 400) and lens speed permitted. When we want extensive depth of field, we would select f/16 or f/22 instead. Granted, f/11 provides relatively good depth of field, but not as great as with f/22.

Verdict: Not very useful, as the system is not adequately flexible.

Landscape Program "LA"

This mode is virtually identical in concept to "HF", and specifically intended by Nikon for landscape photography.

Recommended lens and exposure method: Wide angle to short telephoto AF lenses and Matrix metering. You may sometimes have to use a tripod since slow shutter speeds are chosen in low light. Nikon's advice, to use faster film, is too generalized. Particularly in landscape pictures, you want all fine detail reproduced with the highest resolution. This end is better achieved with ISO 100 than ISO 400.

Performance test: In field work, Landscape Program selected apertures from f/5.6 to f/16, whenever focal length, lens speed and brightness permitted. This was often equivalent to what an experienced photographer would have chosen.

It is important to remember that landscapes taken with wide-angle lenses frequently include large sky areas. Even with the Advanced Matrix metering of the N90s/F90X, this can lead to underexposed foregrounds. In such situations, point the lens downward to meter the land alone. Then recompose (with AE Lock or in Manual mode) and you'll get an exposure optimized for the foreground.

Verdict: Occasionally useful, but will not satisfy the experienced photographer who may well select a different f/stop and metering approach.

Sport Program "SP"

This Program is designed to select the relatively fast shutter speeds required when using long focal length lenses in order to minimize motion blur from camera or subject movement. If the exposures are too short, however, any movement is unnaturally frozen.

Recommended lens and exposure method: The focal length of the lens should be between 80 and 300mm and with a wide maximum aperture such as f/2.8. When used in sports situations, this Program often calls for ISO 400 film to allow for faster shutter speeds except on bright days. Nikon recommends the use of Continuous AF mode with Continuous film advance; this is logical

with fast moving subjects. Matrix metering is, once again, the best bet as there is rarely time for precise metering.

Performance test: In use, the "Sport Program" selected speeds of 1/250 or 1/500 whenever it was possible with existing subject brightness, film speed, and lens speed. Unfortunately, the camera cannot judge the difference between high speed action and moderately fast motion. Nor can it read your mind to determine the effect you want to create.

Verdict: Partially useful but keep an eye on the shutter speed. At 1/250 sec. it may be too long, unless you want some motion blur. At 1/500 sec. it may be too short, freezing a high-jumper in mid leap.

Close-up Program "CU"
This Program sets the camera for close-up photography. While the chosen settings are rarely appropriate for high magnification Macro photography, this Program does provide generally good close-up results with "macro zoom" lenses.

Recommended lens and exposure method: Contrary to the N90s/F90X's instruction manual, normal focal length lenses up to mid-telephoto lenses can be used. However, we would not recommend Macro lenses. The Close-up Program selects apertures between f/4 and f/5.6 providing fairly shallow depth of field but hopefully, rendering the entire subject sharp with such lenses.

Performance test: This Program selected f/4 with lenses under 28mm and f/5.6 with 28mm and longer, with the resulting magnification between 1:10 and 1:6. In real close-up photography (from about 1/4 x to greater magnification) and especially in true macro photography (from 1/2 life-size and up), this Program is completely useless because the depth of field at these apertures is simply not adequate in such extreme close-up work. You generally need smaller apertures such as f/16, as the magnification ratio increases.

Verdict: Use with macro zoom lenses for quick, hand-held pictures, but switch to another mode for precise macro work when greater control is required.

Shutter Priority Mode

After you preselect the exposure time and touch the shutter button, the camera's computer calculates the appropriate aperture. To calculate the aperture, the computer evaluates the subject brightness and the film speed, in relation to the set exposure time. The computer receives the information with respect to the smallest and largest possible apertures via the appropriate contacts from the lens' ROM. As soon as the shutter release is completely depressed, the computer sets the calculated aperture on the lens using a very fast motor and the spring-loaded aperture lever. After the mirror flips out of the way and the shutter opens, the film is exposed for the selected amount of time.

When using the N90s/F90X's Shutter Priority AE mode, the photographer selects a specific shutter speed in 1/3 stop increments, or in 1 stop increments on the N90/F90. As stated above, the camera automatically selects the appropriate aperture, depending on the subject brightness and the film speed.

Use Shutter Priority AE mode when a specific shutter speed is required and the aperture is of secondary importance. This mode is especially recommended when photographing moving objects or with long focal length telephoto lenses to reduce the risk of image blur.

Procedure: Set the aperture ring on the lens to the highest f/number and lock it in. Select the "S" mode using the MODE button and the Command Dial. Select the desired metering pattern, the AF mode and the AF detection field size. Once you have considered the conditions of the situation, select the appropriate shutter speed. Aim at the subject, slightly depress the shutter release. The shutter speed along with the camera-selected aperture will appear in the viewfinder and on the LCD panel. If you want to use a different shutter speed, simply turn the Command Dial. With the newly selected speed, the camera will indicate the new f/stop selected by the system.

Applications

If you want to deliberately control the motion of a subject, shutter priority AE mode is the best choice. It is logical that longer exposure times and moving objects will produce some blurring. A race car

that shows up as a colorful streak in the picture may win the race, but it won't win any photo contests unless you pan with the motion to record the subject reasonably sharp, against a blurred background.

On the other hand, it is not always appropriate to "freeze" all movement. A gymnast that looks like a frozen pillar will not look natural to most observers. The art of correctly rendering moving objects consists of selecting a suitable shutter speed, not so slow that movements are badly blurred and not so fast that movement is no longer visible. If you tried this before and were disappointed with the results, here is some consolation: even famous sport photographers discard 95% of their pictures in search of that one which will make the cover of a national magazine.

When shooting with long exposure times, rest the camera on a firm support. Use the self-timer or a remote triggering cord to prevent vibration during shutter release. And don't forget to close the built-in eyepiece shutter! When the eye is up against it, light enters the viewfinder and may cause erroneous metering.

Compatible Lenses

Only lenses with built-in ROM chips such as AF Nikkor lenses and AI-P Nikkor lenses can be used. Lenses without electrical contacts, with fixed apertures, or those where no aperture value transmission is possible, cannot be used with shutter priority AE mode.

Appropriate lenses: The most suitable lenses for shutter priority are telephotos with focal lengths of about 80mm to 500mm. Considerably shorter or longer focal lengths are generally only used for specific subjects such as an entire group of Soap Box Derby participants or distant wildlife.

Using conventional lenses: If you try to use a conventional lens in the shutter priority mode, the N90s/F90X sets off a warning signal by flashing the "S" symbol. The camera also switches automatically to aperture priority AE mode with center weighted metering. Again, this will prevent an improperly exposed photograph, but the result may not be exactly as intended.

With non-AF lenses, there is no f/stop display in the viewfinder and Matrix metering cannot be accessed. We recommend that you set the camera to aperture preferred AE mode and center-weighted or Spot metering.

Appropriate films: We recommend films with speeds of ISO 200 to 400. For specific subjects that require substantially slower film speeds, you will rarely use the shutter priority mode.

Error Warnings

Grossly incorrect exposures are actually impossible because you are immediately alerted to any problems. One glance at the viewfinder display will give you all necessary information. A variety of symbols are used to relay warning information:

"EE" If this appears in the viewfinder instead of the f/stop value, you forgot to set the aperture ring on the lens to the smallest opening (highest f/number).

"HI" This indicates that the subject is so bright that it is beyond the metering range of the N90s/F90X and there is danger of over-exposure. Use a higher shutter speed, lower ISO film, or a neutral density filter.

"LO" Here you are warned that there is not enough light, and an underexposed photograph could result. In these cases, you should use a faster film, longer shutter speed, or flash.

Aperture Priority Mode

The basic principle of aperture priority AE mode is that the photographer selects a specific f/stop and the system responds with the corresponding shutter speed, automatically. After pre-selecting the aperture on the lens ring and activating the metering system by touching the shutter release, the camera's computer calculates the appropriate exposure time. Since the N90s/F90X works with full-aperture metering, like all modern cameras, the diaphragm does not close to its actual working aperture while focusing and metering. To calculate the required exposure time, the aperture setting of the lens is electronically transmitted to the CPU. Only after the shutter release button is fully depressed is the lens closed (automatically) to its working aperture by spring action. At the

In this idyllic scene, the surroundings are just as important as the primary subject. Using Aperture priority mode to select the right f/stop (confirmed with depth of field preview) and focusing on the most suitable point, produced just the desired effect. ⇨

same time the mirror flips up (out of the light path) and then the shutter opens.

Procedure: While pressing the MODE button, turn the Command Dial until "A" appears in the LCD panel. Select the AF mode and field size, frame your subject, and select an appropriate f/stop on the aperture ring. Lightly press the shutter button and the selected aperture appears on the viewfinder and external LCD panel together with the camera calculated exposure time. If you want to change the f/stop, simply turn the lens' aperture ring and the new exposure time will appear. As long as no warning appears in the viewfinder display, the camera's metering system has determined that there is a proper exposure and you can concentrate on aesthetics. (The exposure is not always optimal, of course, especially with light or dark subjects, as discussed earlier in this guide).

Applications
Aperture priority mode is useful in situations where depth of field (either extensive or shallow) is of utmost importance.

Depth of field preview: The human eye has very limited depth of field adjustment and cannot focus close-up and on infinity at the same time. For that reason, it is not a totally dependable tool for judging depth of field. Nikon does include a depth of field preview button, however. It's located right next to the lens, your middle finger should touch it when holding the N90s/F90X's grip. When in aperture priority or manual mode, press the button while looking in the viewfinder, and you will be able to estimate the range of apparent sharpness. Since the screen darkens, stop down one f/stop at a time, allowing your eyes to accustom to the dim view.

Compatible Lenses
Should you use a traditional, non-AF lens with mechanical aperture transmission (that is, without a ROM chip), the camera will display "-" instead of an aperture value. This means that the N90s/F90X can no longer use Matrix metering and will automatically switch to center-weighted metering. The aperture priority AE mode, however, continues to work properly. Unfortunately, you cannot see the aperture value in the viewfinder and have to look at the lens' aperture ring to determine it.

For non-AF lenses that do not have any kind of aperture transmission, such as adapters, bellows units, slide duplicators, and specialized lenses, expect "-" to appear again. The N90s/F90X will automatically switch to "working aperture mode."

Appropriate lenses: Any lens, especially wide angle is suitable. Keep in mind, however, the limitations which occur when using non-AF lenses.

Working Aperture Mode
In this aperture priority mode, the camera calculates the exposure while the picture is being taken. You focus and compose the scene at a wide aperture, and stop down to the desired f/stop when ready to shoot. While the exactness of the exposure time does not suffer, the shutter speed displayed in the viewfinder and on the LCD panel are meaningless. Since Matrix metering is not possible, the N90s/F90X automatically uses center-weighted metering.

Example: Let's assume that you are using a screw-mounted 400mm f/5.6 lens with a T-adapter. To focus, you have to open the lens fully to f/5.6. In this case, you can even use the focus assist indicators. Before exposing the frame, you must manually adjust the aperture to the value you require, f/11 for example. You will notice this change (contrary to wide open metering) by a darkening of the viewfinder. During the exposure, the N90s/F90X measures the scene brightness in a few milliseconds and sets the shutter speed it deems necessary a result of this reading.

The disadvantages of working aperture mode are reduced ease and speed of operation. Additionally, actual exposure time is only displayed in the viewfinder and on the central LCD panel after the exposure.

Appropriate films: You must decide on the best film choice based on where and with how much light you are going to shoot. In churches or in museums, it is better to use ISO 400 and get barely sharp shots at 1/60, than to use ISO 100 and get blurred images at 1/15. To shoot in theaters or at concerts (when permitted), the same considerations apply.

You may wish to avoid ISO 1600 or ISO 3200 films which are quite grainy, unless striving for an artistic effect. When shooting

on a tripod outside at night, for example, the long exposure times are rarely a problem. So, when possible, stick with ISO 100 to 400 films for superior sharpness, grain, and color reproduction.

Error Warnings
There are two warnings which could potentially appear in the viewfinder and on the LCD: "HI" and "LO." See the section on Shutter Priority AE, Error Warnings (page 86) for a detailed explanation of these warnings.

Reciprocity Failure
This is a phenomenon encountered during very long exposure times when the film no longer reacts in a linear fashion to the light. In other words, the results of a ten second exposure may not be twice that of a five second exposure. Reciprocity failure generally starts occurring in daylight balance films at about 1/15 second. Increased exposure (+ compensation, even longer exposure time or a wider aperture) is necessary to compensate for this effect. With the N90s/F90X, you may not need to worry about exposure times of up to 2 seconds, since Matrix metering tends to expose relatively dark subjects correctly. When using even longer exposure times, however, corrections become necessary. These can be set easily and exactly on the N90s/F90X. How much to correct depends on the film. You should either bracket or request a technical sheet from the film manufacturer giving reciprocity data.

Manual Exposure Mode

In this mode, the N90s/F90X essentially becomes a completely manually-operated camera. The user selects both shutter speed and aperture, based on the camera's light reading, previous experience with such situations, or on a reading taken by a separate meter. In many cases, an expert photographer using manual selection and center-weighted or spot metering can achieve better results than the N90s/F90X automatic exposure systems.

Photojournalists typically use Manual mode, insisting on full control of all aspects of the image.

Procedure: While holding down the MODE button, turn the Command Dial until "M" appears in the LCD panel. After this point, the aperture is set on the lens and the shutter speed is set with the Command Dial.

Applications

Generally, you would only use this mode in situations where you would rather not leave the exposure decision-making to the camera. As tedious as manual methods are, they sometimes can be the best for difficult subjects. Consider a situation involving soccer players clothed in white on a green field. Depending on the proportion of field to player in each of the 8 metering areas of the Matrix, the exposure could be correct, or under-, or overexposed. In a case like this, you can set the exposure values manually after taking a meter reading of the mid-toned grass, perhaps. This will prevent underexposure caused by the white uniforms. Switch the camera to "M", take the meter reading and set the corresponding aperture and shutter speed. This exposure value will remain constant through the entire series of shots. Unless the light changes, your exposures should all be correct.

Compatible Lenses

All recent Nikkor lenses are compatible, but for f/stop readouts in the viewfinder (and Matrix metering) use an AF-Nikkor.

Appropriate lenses: Any focal length will work well in this mode.

With non-AF lenses: When using a manual focus lens, the camera automatically switches to center-weighted metering. Although no aperture value is shown in the viewfinder or on the central LCD, the analog scale does show the correct exposure comparison.

Appropriate films: Use whatever film will achieve the desired effect.

This picture of unusual stone formations contains a wide range of tones. ⇨ Exposure was calculated for the middle-gray values and the film was processed so that an enlargement could be made on medium-grade enlarging paper to obtain bright whites, solid blacks, and good mid-range tonal gradation.

Appropriate metering modes: Even though Matrix metering works in manual mode, this is a contradiction in itself. You either want to use auto-exposure or you want to measure and set your exposure using a very specific strategy. This does not coincide with an automatic exposure correction that is unpredictable, and changing as subject reflectance changes such as with the number of white jerseys in the frame at any given moment.

Using the Metering Scale

Frame your subject and lightly touch the shutter release button. Set an f/stop and a shutter speed. Check the analog scale on the right side of the viewfinder display panel. This indicates whether you are overexposing (+) or underexposing (-) in comparison to the meter's recommendation. The scale denotes one stop over- and underexposure in 1/3 stop increments. If you want to expose in accordance with the meter, change the aperture and/or the shutter speed until the pointer is at "0", denoting no deviation.

Example: Let's assume that the exposure time is set at 1/125 second, the aperture at f/8, and the light scale shows +1. You can either leave the aperture at f/8 and change the exposure time to 1/250. Or simply leave the exposure time unchanged and move the lens' aperture ring to f/11. In either case, you reduce the amount of light which will reach the film by one stop. Now the pointer moves to "0", denoting correct exposure settings.

From this point on, you can vary the aperture/shutter speed combination while maintaining correct exposure. Keep in mind that to maintain equivalent exposure, for every decrease in time, you have to open the lens one stop, and vice versa. In AE modes the camera does this automatically, but in manual mode you are on our own.

Targeted Metering

When metering the subject, you can make use of the reference circles etched on the focusing screen which denote the spot and center weighted metering areas. With contrasty subjects, center-weighted metering might not do the trick. You will need to walk up to the subject, a tanned model on a beach, perhaps, until it fills the frame. Set a suitable f/stop and shutter speed. Ignore the warnings on the analog scale! Now move back to the desired

shooting position for a pleasing composition (or switch to spot metering and take a reading of the nose area). You will be exposing for the subject, and not for the bright sand as the meter now suggests. The exposure will remain constant, unless you change the f/stop or shutter speed. In Manual mode, your settings are held permanently, the camera will not make exposure changes. Unless the light changes while you are waiting for a smile, the exposure will be correctly optimized for the subject.

Choosing the metering point: In the example above, we took the meter reading from a tanned face. When deciding what to meter remember this. Areas of medium reflectance are best (grass, the bark of some trees, etc.). Unusual reflective properties (either mostly black or white) require special exposure corrections: "+" compensation for white and "-" for black. The best solution for properly exposing subjects of unusual reflectance is to meter a Kodak Gray Card® (18% gray card) in identical lighting. In a pinch, a meter reading off the palm of your hand with one stop plus compensation is nearly identical to a gray card reading.

The "Bulb" Setting
The name "bulb" ("B") goes back to the beginnings of photography, when shutters were pneumatically released with a rubber bulb. The shutter stayed open as long as there was pressure on the bulb.

Procedure: In situations where an exposure time of 30 seconds is not adequate, switch to manual exposure mode and turn the control dial until "B" appears in the LCD. With this setting, the shutter will remain open as long as the shutter release button is depressed. The N90s/F90X will not provide metering assistance, so you will need some guidance on exposure times, such as with fireworks. Photography books (such as those published by Kodak Books®) and magazines often provide useful hints on low-light photography. Use a tripod and trip the shutter remotely. The MC-20 is useful for this purpose to prevent camera shake. You can even pre-program exposure times from 1 second to 9 hours 59 minutes, 59 seconds. Long exposure times can also be programmed using the Multi-function Back MF-26, see page 157.

Manual Exposure with Manual Focus

The statement that autofocus photography is particularly fast is only completely true when the subject is in or near the center of the frame: and thus, within the focus detection brackets etched on the screen. Even Continuous AF does not have a chance if the subject is located near the edge of the frame. Therefore, you must first frame small subjects and lock in this focus setting with AE-L. Only then can you select your composition and shoot. All this can be done just as fast manually with some practice. With small (or extremely fast) moving subjects, there is a specific manual focus method which works extremely well.

For moving subjects, set your camera to focus mode "M" and manually focus on a point the subject will soon reach. Trip the shutter as soon as it does so. You can use the focus assist signals to do this.

With the help of the built-in light meter, select an aperture/shutter speed combination that will give adequate depth of field, but still allow a short enough exposure. Because of the relatively small apertures that result from ISO 200 or 400 films, you have a fairly broad choice of options on bright days.

When something interesting happens at the pre-selected spot, depress the shutter release button. At first, your reaction time may be too slow, and you'll miss the subject. With experience, you should begin getting some dynamic action shots.

Using the Sharpness Indicator: Use the focus indicator to help decide when to shoot. Trip the shutter at the right instant to assure a sharp image. Manually pre-setting focus on a point a moving subject will eventually reach (such as first base) is a technique still used by many sports photographers. It's quick and simple, guaranteeing sharp pictures once you become adept at triggering the camera at the right instant. No time is lost while the autofocus system is seeking focus, or trying to find a small subject. An alternate method can be performed with the MF-26 Multi-function Back, see page 162 for details.

Selecting a Lens

Lens Quality

The quality of a lens can be defined by many standards. You can look at its resolving power, sharpness and focal range, distortion, chromatic aberration, or mechanical durability and focusing speed.

Distortion
Optical distortion is a lens aberration which does not affect image sharpness but rather alters the physical shape of objects. There are two distinct varieties, pincushion and barrel, which are the bowing of lines near the edge of the frame inward and outward respectively. Distortion is caused by positioning of the aperture in relation to the lens elements and can be reduced or corrected by the addition of moving lens elements. However, barrel distortion cannot be eliminated in lenses with an extremely wide angle of view and can actually be a desired photographic effect.

Focal Optimization
In the past, lenses could not be optimized to focus both close and on infinity; they were fully corrected only for a certain distance. This meant that their optical flaws were minimal at the optimized distance, but as the focusing distance changed, image quality suffered. Now, lenses can be made that not only have two main element groups that move toward each other, but also a third group that moves in between them to correct for this aberration. With wide-angle lenses this means that when focused at or near their minimum focusing distance, corner-to-corner and edge-to-edge sharpness on the film plane is maintained. Nikon's Close Range Correction (CRC), incorporated in some lenses such as AF Micro Nikkors, produces high image quality for both normal and close-up photography.

Chromatic Aberration
Chromatic aberration is an undesirable effect most prominent at wide apertures in long focal lengths. Red, green, and blue light do

not focus on the same plane, resulting in color fringing around the edges of a subject and reduced sharpness. All modern telephoto lenses are achromatic, or corrected for two wavelengths of light, so that real "rainbow effects" are very seldom seen. The highest quality telephoto lenses are fully corrected so that all three wavelengths will focus at the same point on the film plane. ED Nikkor lenses achieve such "apochromatic" correction through the use of low dispersion (LD) glass or extraordinary dispersion (ED) glass. These types of elements do not disperse light as much as ordinary optical glass. As a result, all colors of light are focused more accurately on the film plane, eliminating color fringing even at wide apertures for extreme sharpness.

Internal Focusing
When using the autofocusing capabilities of older telephoto lenses, the main element groups are moved with respect to each other. In others, all of the optical components are moved as a unit, resulting in a marked change in the overall length of the lens. The longer the focal length, the longer the extension, making telephoto lenses cumbersome and slow to focus. The solution is Nikon's line of internal focusing (IF) telephoto lenses. Focusing is accomplished by moving one component between the two main groups. The movement is extremely short and the overall length of the lens therefore remains constant. Such lenses are unbeatable in AF mode, and can be combined with a "floating element". This automatic correction results in even further improved image quality.

Compatible Lenses

Be advised that certain non-AI Nikkor, fisheye, AI, telephoto and zoom lenses, and older PC Nikkor lenses are incompatible with the N90s/F90X. Furthermore, older Reflex Nikkors and the Nikon F3AF's AF lenses and converters should not be used. If in doubt, check with Nikon or your owner's manual for details.

This image is a perfect example of optical distortion caused by an ultra wide-angle lens.

AF-I Nikkors

The unique feature of the AF-I Nikkors is that they have a built-in, super-fast focusing motor. When mounted on an N90/F90 series camera, the body's focus motor is disengaged. The lens motor provides lightning fast autofocus with the N90s/F90X; it is even 25% faster than with the N90/F90. The best part is that the lens does not have to be switched from autofocus to manual mode for override. Simply turning the ring allows for instant manual focus fine-tuning.

Note: Since AF-I lenses require a unique interaction with the camera, they are only fully compatible with the F4 and N90/F90 series cameras. With other camera models, AF-I lenses can only be focused manually.

AF-D Nikkors

The ROM chip in conventional AF Nikkor lenses only sends information to the camera pertaining to the number of motor revolutions necessary to focus. The new AF-D Nikkor lenses, on the other hand, provide the camera with the actual distance to the subject. Because of this, more accurate and sophisticated flash and 3D Matrix metering are possible with the N90s/F90X.

A Tour of Nikkor Lenses

Nikon is respected as the manufacturer of some of the finest quality lenses available today. Here is a brief overview of some of the most popular. For additional information, we recommend the *Magic Lantern Guide to Nikon Lenses.*

Extreme wide-angle and fisheye: Fisheye lenses are used for their impressive angle of view and their extreme barrel distortion. For occasional special effects, the Nikkor 6mm f/2.8 is an interesting (and incredibly expensive) toy to have, but a 220° angle of view and circular image is not always appropriate for everyday photography. The Nikkor 16mm f/2.8D AF fisheye with 180° coverage is a lower-priced and less heavy alternative which produces a full-frame image. Wide-angle lenses which offer straight-line rendition of subjects include the Nikkor 13mm f/5.6 (118°) and the Nikkor 15mm f/3.5 (110°).

Nikkor 6mm f/2.8

Nikkor 8mm f/2.8

Nikkor 16mm f/2.8

These cross-sections show the internal differences between a super-fisheye lens and the rectilinear-perspective 16mm.

The tremendous coverage of these lenses nearly precludes the use of front element filtration. Vignetting is a common problem caused when the mount of the filter appears in the frame and darkens the edges or corners. Also, it is not uncommon to see fingers, the tripod or a branch which is physically behind the lens end up in the photograph, with the 6mm fisheye lens.

These fisherman in Algarve were photographed using a 35mm lens. The depth of field and angle of view of shorter focal length lenses are excellent for depicting people in their environments.

Wide-angle: The lenses in this range are the widest most photographers ever explore. This has to do with price and availability as well as the fact that a camera showroom does not do justice to a wider angle of view. The trick to using a wide-angle lens is to maximize its sweeping perspective. Do not point the camera directly at the subject, but rather get close and capture the subject at an angle. The Nikkor 20mm f/2.8 AF is recommended for landscape, interior and even architectural photography. This lens has proven to be a high quality performer in extensive use. A less extreme option for these applications is the Nikkor 24mm f/2.8 N AF or the new Nikkor 28mm f/1.4 D AF. Additionally, the bright Nikkor 35mm f/2 AF is an excellent lens, a favorite of photojournalists.

Wide-angle zoom: Two versatile choices in this category are the Nikkor 24-50mm f/3.3-4.5 AF and the 20-35mm f/2.8 D AF. Both are versatile because they have broader applications than just straight-forward, wide-angle photography.

Normal lens: If you were to select a single "normal" Nikkor, the 50mm f/1.4 N AF should probably be your first choice. It offers outstanding optical quality together with a wide maximum aperture useful in low-light situations without flash. For macro fans, the Micro-Nikkor 60mm f/2.8 AF is an excellent, albeit expensive, choice. This lens offers a reproduction ratio of 1:1 (life-size) and can focus out to infinity, making it an excellent general-purpose lens.

Normal zoom: The top of this list includes the Nikkor 28-70mm f/3.5-4.5 D AF and the 35-70mm f/2.8 D AF. Less expensive alternatives include the 28-85mm f/3.5-4.5 N AF, the AF 35-105mm f/3.5-4.5 N AF, and the 35-135mm f/3.5-4.5 N AF. With today's zoom lenses, there need not be concerns about quality; they are absolutely first-rate.

Mid-range zoom: The economical Nikkor 70-210mm f/4.0-5.6 D AF is an alternative to buying several expensive fixed focal length lenses. The Nikkor 80-200mm f/2.8 D ED AF is expensive, but also capable of incredible image quality even at f/2.8. It is mechanically solid, with exceptionally smooth manual focusing, but is rather cumbersome and heavy. It was upgraded to Type-D in 1992, perfect for 3D Matrix metering with the N90s/F90X.

Telephoto zoom: The Nikkor 75-300mm f/4.5-5.6 AF offers a wide focal range in a relatively compact package. It is particularly useful in sport or news photography from the sidelines, allowing you to react quickly to sudden changes in subject distance. Although not extremely fast, it is capable of pro caliber image quality.

Short telephoto: The Nikkor 85mm f/1.8 AF is a relatively economical AF fixed focal length Nikon lens that produces exceptional quality. Thanks to its fast f/1.8 aperture, this lens allows you to blur away a distracting background. The expensive Micro Nikkor 105mm f/2.8 AF and Micro Nikkor 200mm f/4 IF are excellent lenses that take not only macro shots but just about anything else. Magnification is infinitely variable from a full 1X (life-size) to 1/10X at infinity. New from Nikon is the Nikkor 105mm f/2.0 D DC AF portrait lens. A Nikkor DC lens allows you to vary the amount of background blur at any aperture, ideal for portraiture.

Medium telephoto: Nikon's 180mm f/2.8 N ED IF AF provides very quick autofocusing, thanks to an internal focusing mechanism, and also has superb optical quality due to the use of special aberration-reducing ED glass elements.

Super telephoto: Nikon has a truly exceptional lens in the 300mm f/2.8 N ED IF AF. It is the large, expensive lens that is often seen used by sports and wildlife photographers. It is now available as the redesigned Nikkor 300mm f/2.8 D ED IF AF-I with a powerful, built-in focusing motor. Autofocus is lightning fast especially when used with the N90s/F90X. Unfortunately, it has a stratospheric price tag to match its incredible optical quality, which puts it out of the reach of most photographers. A lighter, more compact, and less expensive alternative is the 300mm f/4.0 ED IF AF. While it is not as "fast" (speaking both of f/stop and autofocus operation), its optical quality will satisfy the professional. Should you need an even longer focal length, the new Nikkor 400mm f/2.8 D ED IF AF-I and the acclaimed 500mm f/4.0 P ED IF are now available. The last word in super-telephoto lenses is the fully N90s/F90X compatible 600mm f/4.0 ED IF AF-I for distant wildlife and sports action. Its image quality is commensurate with the price.

Micro lenses: Nikon calls their macro Nikkor lenses "Micro" for reasons we do not understand. Whatever the terminology, these are particularly well-corrected for superior results in close focusing. They also produce exceptional image quality at any distance up to infinity. Close Range Correction (achieved with floating elements) is used to maintain this performance level. Although used in a few other lenses as well, CRC is most valuable in the Micro Nikkors, such as the 105mm f/2.8 AF, the 60mm f/2.8 D AF and 200mm f/4D AF. All are optically superb, offering a focus range from infinity to Macro for full versatility. For nature photography, we prefer the longest focal length as it offers a greater camera to

By using a lens with a focal length of 80mm to 200mm, the convergence of vertical lines can be minimized. In addition, longer focal length lenses give the illusion of compressed space. The foreground, middle ground and background elements in this photograph appear to be quite close to each other.

subject distance. The extra working room facilitates placement of flash and reflectors, while reducing the likelihood of scaring away shy insects.

In the manual focus sector, both the 105mm f/2.8 IF Micro, 200mm f/4 IF Micro, and the 120mm f/4 IF Medical are compatible with the N90s/F90X in "M" and "A" modes and with center-weighted metering. The medical Nikkor has a built-in ring flash whose output is automatically linked to the focusing distance, resulting in perfectly exposed macro shots.

For magnification beyond life-size, you can reverse-mount lenses with the front element towards the camera. For that purpose, reversing ring BR-2A is offered for Nikon cameras.

60mm f/2.8 AF Micro Nikkor Lens

Perspective Control: These lenses are most often used in architectural photography. Their optics actually "shift" to avoid converging lines, making the images look more realistic. When using a shift lens, you can shoot from a low angle and from a relatively close distance without worrying about linear distortion. It can be used on the N90/F90 series cameras, but the complexity of the lens' optics make it incompatible with autofocus systems. You can use the 28mm f/3.5 PC and 35mm f/2.8 PC in "M" or "A" modes, with center-weighted or spot metering. If you plan to invest in one

106

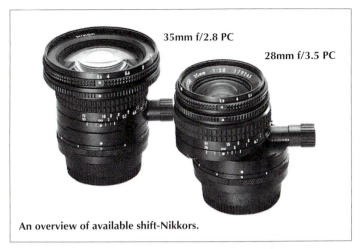

35mm f/2.8 PC

28mm f/3.5 PC

An overview of available shift-Nikkors.

of these specialized lenses, consider the 28mm model, because in many instances the 35mm's angle of view is not wide enough.

Non-Nikkor Lenses

As we have seen, Nikon has an extensive range of AF lenses available. By the time this is published, there will be even more. You may, however, wish to explore the options offered by other companies. It is important to note, however, that while Nikon guarantees flawless performance of the N90s/F90X with Nikon lenses, this guarantee does not cover lenses made by other manufacturers. If you purchase a Nikon-compatible lens from a reputable manufacturer (including Tamron, Tokina and Sigma), the risk is not very high. These firms have been in the photographic industry for many years, and offer reliable equipment with fairly quick warranty repairs.

It should be noted that at the time of writing, a couple of independent lens manufacturers had announced a lens with the chip required for distance transmitting capability. We assume these will work with the N90s/F90X's 3D Matrix metering and enhanced Matrix flash capabilities.

Range: All three manufacturers (especially Tamron and Sigma) offer a wide range of Nikon-compatible autofocus lenses; only a few are mentioned here. Sigma has a 28-70mm f/3.5-4.5, a fast 75-300mm f/4 APO, and a particularly brilliant 70-210mm f/3.5-

4.5 APO. Their fixed focal length 24mm f/2.8 and Macro 90mm f/2.8 (stepless to 1:2, using the included close-up filter, 1:1) are worth considering. A runner-up is the relatively economical 400mm f/5.6.

Tamron offers a 24-70mm f/3.3-5.6, a 70-300mm f/4-5.6, an ultra-compact 28-200 f/3.8-5.6, a continuous-focus macro 90mm f/2.5, a 35-105mm f/2.8 constant aperture, a 70-210mm f/2.8, a 300mm f/2.8 and more. Most are lightweight and of high quality.

Tokina also offers several lenses worth considering, including the 17mm f/3.5, 300mm f/2.8 APO, 400mm f/5.6 APO, 24-40mm f/2.8, 80-200 f/2.8 APO, and 100-300mm f/4 APO. Their lenses are reasonably priced and incorporate good to excellent optics.

Lens Accessories

Teleconverters

Teleconverters fit between the camera body and lens to effectively increase the focal length of the lens. For example, Nikon's TC-16A, increases the focal length by a factor of 1.6x; a 200mm lens, used with the TC-16A, becomes a 320mm. The down side is that the effective maximum aperture becomes smaller, and the image quality of a lens with a converter is lowered. Nevertheless, for most applications, the image quality produced with a teleconverter of decent quality is perfectly acceptable.

Note: Nikon makes only one teleconverter which will maintain autofocus with AF lenses. The TC-E models are compatible only with the AF-I Nikkor telephotos.

Macro Accessories

By the most strict definition, only pictures with a magnification ratio of 1:1 (life-size on the film frame) or higher are truly "macro". However, the term macro is often loosely used to describe a 1:2 magnification (1/2 life-size) as well, and close focusing zooms, capable of a 1:4 (or 1/4 life-size) reproduction ratio, are now routinely called "macro zooms".

Extension tubes: The only extension tube that is compatible with the N90s/F90X is the PK-11A. The PK-11 is not, so be very careful when

An Overview of close-up accessories

AF-Micro-Nikkor
2,8/105 mm

Micro-Nikkor
4/200 mm

Medical-Nikkor IF 4/120 mm

Nr. 0 Nr. 1 Nr. 2 Nr. 3T Nr. 4T Nr. 5T Nr. 6T

AF-Micro-Nikkor 2,8/60 mm

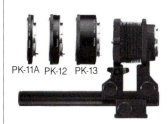 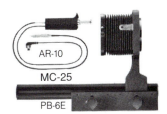

PK-11A PK-12 PK-13

AR-10

MC-25

PB-6E

PS-6

purchasing. Extension tubes do allow the lens to focus closer, but some prefer true macro lenses or supplementary close-up filters. They are easier to use, maintain full automation and are more flexible.

Close-up filters: Supplementary close-up filters (sometimes called close-up lenses or "plus diopters") are the least expensive option for extreme close-up work to 1/2 life-size. When screwed into the lens' filter thread, they shorten the minimum focusing distance. You can, therefore, get closer to your subject and increase the magnification ratio. This can reach even 1:1 (life-size), depending on the lens. Nikon makes close-up filters with +0.7, +1.5 and +3 diopter in the 52mm filter size. For superior image quality with lenses from 80 to 300mm, consider Nikon's T-designated achromatic close-up lenses +1.5 and +2.9 diopters in both 52mm (called 3T/4T) and 62mm (called 5T/6T) filter sizes.

When using supplementary close-up lenses, you should stop down to the smallest practical aperture, such as f/16. This will compensate for the reduction in optical quality, producing superior sharpness. Besides, depth of field is so minimal in macro photography that stopping down is often essential to record the entire subject in sharp focus.

Autofocus with close-up filters: We have found the AF Nikkor telephoto zoom lenses are well-suited to macro photography with these accessory filters, especially the T-designated series. In extreme close-up work (1/2 life-size or greater), it is best to focus manually, to precisely set the exact distance.

Bellows units: The bellows unit is the most professional macro accessory, but it only allows stepless adjustment in the close-focus range, and can only be focused manually. The original Nikon Bellows unit PB-6 is recommended, thanks to its stable and precise design. In order to simultaneously release the shutter and close the lens to the working aperture, you will need the double cable release AR-10. To attach it to the N90s/F90X, the MC-25 adapter is necessary.

The PG-2 focusing stage is a useful instrument, allowing camera to subject distance to be adjusted in minute increments. At high magnification, adjusting focus is best achieved by moving the camera toward and away from the subject.

Slide duplication: Duplicating slides falls within the realm of macro photography. Duplication guards against loss of the original when sending slides to publications, ad or stock agencies, or to photo contests. For under $200 U.S., you can purchase a simple slide duplicator. In practical use, this relatively cheap Nikon accessory has proven sharper than a non-Nikon that is far more expensive. The only disadvantage of the simple units is that the reproduction is slightly larger than 1:1, meaning that some of the original is cut off. If you want exact 1:1 or steplessly adjustable ratios, buy the PZ-6 duplication accessory for the PB-6 bellows unit. A macro lens is required as well. Use film specifically made for duplicating slides which is processed E-6. These special slide films are designed to have lower contrast and are the best choice for most duplication purposes.

Flash Photography with the N90s/F90X

The N90s/F90X has one of the best flash automation systems of any camera on the market, particularly when used with the SB-25 or SB-26 flash unit. The only disadvantage is that with a multitude of options, numerous decisions must be made. We have tried to explain the many flash exposure options the N90s/F90X offers in a straight-forward manner. For a more in-depth look at Nikon's SB-25 or SB-26 flash, we recommend reading the *Magic Lantern Guide to the Nikon SB-25/SB-26 Flash System.*

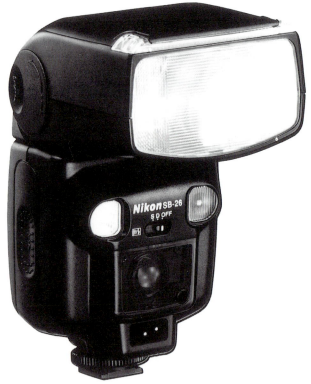

SB-26 AF Speedlight

Groundwork on Flash

Flash techniques can be difficult to master, especially with the complex flash units being made today. An advantage of these sophisticated systems is that it is fairly easy to get passable results using the basic automatic settings. However, it can be time-consuming to learn the features that put you in control of flash lighting. But flash is a powerful tool that, if mastered, can reward the photographer with vast picture-taking possibilities and results that are a cut above the ordinary! Before diving into this topic, one statement needs to be made about understanding flash photography. *It takes time and practice to master flash!*

Because flash lighting cannot be seen before the picture is taken, learning flash is a very difficult process. Do not expect to comprehend all the theory and instantly put flash techniques into practice after simply reading this or any other explanation of flash. This book will get you up and running with flash, but it will still require some time before using flash becomes second nature.

Color Temperature
The light from most flash units has a color temperature of 5600°K which is close to the color temperature of daylight. Thus, daylight-balanced film should be used for flash photography. Because flash approximates daylight, it is an excellent way to augment the light on overcast days or to soften the harsh light of bright sun.

Flash Exposure Regulators
To begin, understand that the only exposure regulators of manual flash exposure are *flash output, flash-to-subject distance* and *aperture.* We'll start with flash-to-subject distance as it's normally the hardest concept for folks to understand. Flash-to-subject distance is just what it says, the physical distance between the flash and the subject. Even with modern TTL technology, for best results, this concept must be thoroughly understood! Back in the old days, this distance was generally determined by first focusing on the subject, then reading the distance off the distance scale on the lens. This distance is put into a formula to calculate the required aperture for proper exposure. Thanks to modern TTL flash technology, knowing or referring to all of these formulas is unnecessary, just remember the principles.

Guide number: The reason that flash exposure is determined by flash-to-subject distance is because the intensity of the light emitted by the flash decreases as it travels away from the source. This amount of light the flash emits is represented by a guide number, GN for short. The guide number quantifies the relationship between brightness, distance, and film sensitivity and assists in calculating aperture and distance values.

The formula for determining the aperture to use with a given ISO is aperture=guide number/distance. Thus, the higher the number, the greater the output of the flash.

Note: *In the United States, guide numbers are expressed in feet and are consequently 3.3 times larger than corresponding metric guide numbers.*

Distance: The brighter the light, the further it can travel. However, as the light travels from the flash towards the subject, the intensity of the light falls off. In fact, the light falls off at a rate determined by the Inverse Square Law. This law states that light from flash falls off at the rate inverse to the square of the distance the light has traveled.

To illustrate this point, lets look at the rate of light fall off for the SB-25 or SB-26 which are the same power. Using film with an ISO of 125, a subject at 7 feet can be properly exposed at f/22. At 20 feet the aperture must be opened to f/8, if the subject is 30 feet from the flash an aperture of f/5.6 is necessary, and an aperture of f/2.8 must be used for a subject 60 feet away. That's a fairly substantial drop off in power in the space of a few feet. But it is important and a fact of photography we must work with.

Aperture: Aperture is the other means of regulating flash exposure. Using the information in the above example, if the subject is 30 feet away the proper exposure is f/5.6. But if our subject is white and at that same distance, we would probably want to open the aperture to f/4 to record the subject as white. If the subject is black, we would probably want to close down one stop to f/8. (This adjusts for the tendency of the meter to render a scene as 18% gray; thus, we need to lighten whites and darken blacks.) During this whole exercise, the flash-to-subject distance did not change. We changed exposure strictly by changing the f/stop.

The nightmares are just beginning for someone trying to accomplish this with manual flash. Yet, thousands of similar situations were successfully photographed with "old" flash technology because photographers understood the basics of manual flash. But what does this have to do with modern TTL technology? Hold on, we're getting there!

Flash Synchronization

Many wonder why the shutter speed does not affect flash exposure. It's simple, the shutter isn't fast enough! For example, the duration of the burst of light from the SB-25 and SB-26 ranges between 1/1000 to 1/23000 of a second. The light from the flash exposes the film in one, split-second burst. (This is not true with the FP feature on the N90s/F90X.)

For proper results, the electronic flash must fire when the focal plane shutter is completely open. This shutter consists of two curtains which move in sequence across the film. The first curtain opens, uncovering the film for exposure, and then the second curtain closes providing a light-tight cover over the film again. Exposure time is changed by releasing the second curtain either sooner or later. Thus, the fastest synchronization speed for electronic flash is the highest shutter speed at which the first curtain has completely uncovered the film and the second has not yet begun to close. The synchronization speed only indicates the highest possible shutter speed for a flash exposure. The N90s/F90X's vertical shutter design allows a fast sync speed of 1/250 second.

With many cameras, if the focal plane shutter is set at a speed higher than the fastest synchronization speed only a portion of the normal image area is exposed. The remainder of the film area, which was still covered by the curtains during the flash, will be severely underexposed. The N90s/F90X will automatically prevent this error. It will simply refuse to fire a flash at too high a speed, and automatically default to the highest possible synchronization speed.

TTL Flash Control

Nikon introduced TTL (Through The Lens) flash technology in 1980. The basics of TTL operation are rather simple. With TTL

The Optical Path of a TTL-Controlled Flash Exposure

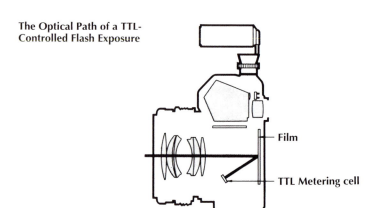

Film

TTL Metering cell

flash exposure, when the shutter is tripped, the flash fires. This light hits the subject then bounces back to the camera. It travels through the lens (and any filters which may be attached) and strikes the film plane. The light is then reflected off the film to a sensor which reads the light as it builds up exposure on the film. Once the sensor and the camera's computer determine the light is sufficient for correct exposure, the camera's computer turns off the flash. Keep in mind, this happens at the speed of light!

Why is this technology so important to flash photography today? With TTL technology, the camera's computer provides the correct exposure regardless of the aperture or flash-to-subject distance (as long as the subject is within the distance range of the flash unit.) TTL has taken the calculations out of basic flash exposure because it reads the light exactly as the film sees it.

The TTL Advantage
Because flash-to-subject distance does not necessarily affect the f/stop with TTL flash regulation (as long as we are within the range of the flash), we can maximize and manipulate aperture and shutter speed to our advantage. We can choose exposure settings to correctly expose for the ambient light, using the flash to supplement the ambient light. We can also set the shutter speed to underexpose the ambient light. This can be as little as one stop to make a busy background go dark or the photograph can look like it was shot at night, even in bright sunlight, by underexposing two or

three stops. This whole time, the flash is providing proper exposure for the subject. We can do this only because TTL provides us with the proper exposure for the aperture selected, regardless of the flash-to-subject distance.

There's a lot more to this than this simple explanation provides. The specifics of how this can be put into practice will be covered later. Just being aware of this and thinking about it though will help prepare you for those sections.

Can TTL Metering be Fooled?
You bet, even with the new flash matrix technology! Be aware that even with matrix metering, the camera's meter is still looking for 18% gray even with flash exposure. White or black subjects can fool the meter and produce incorrect exposures. Size and placement of the subject in the frame can also cause exposure problems. The drawbacks when it comes to exposure will be covered under the appropriate sections. Just be aware that you, the photographer, still must be in charge and that all this technology is still only a tool and not the final word on exposure perfection!

Recommended Nikon Flash Units

The following Nikon system flash units are recommended for use with the N90s/F90X: SB-20, SB-22, SB-23, SB-24, SB-25 and SB-26. This is due to their AF Assist Illuminators, which allow for autofocus even in darkness.

If you rarely use flash, consider the economical and easy-to-use SB-23. If flash photography is part of your day-to-day routine, however, invest in either the SB-25 or SB-26. These state-of-the-art units cannot be surpassed in usefulness and compatibility with the N90s/F90X.

The SB-25 and SB-26
These two flash units incorporate all of Nikon's technological advancements available at this time. Although designed to be fully compatible with the N90/F90 generation of cameras, the SB-25 and SB-26 can be used with all other SLR cameras in the Nikon line. Furthermore, they are easier to use than the earlier SB-24. The SB-25 and SB-26 are similar in most respects, with the

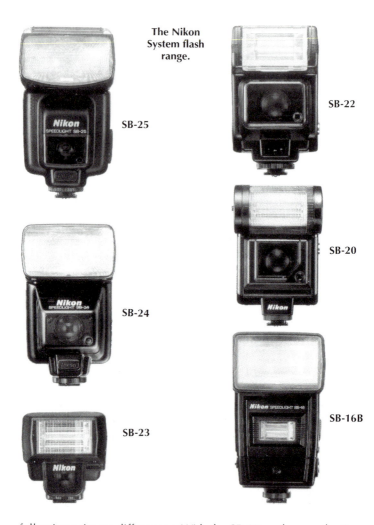

The Nikon System flash range.

SB-25

SB-22

SB-24

SB-20

SB-23

SB-16B

following primary differences. With the SB-25, red-eye reduction is achieved with preflash from the flash tube. With the SB-26, a separate lamp lights up briefly. The SB-26 also offers a wireless remote feature (see page 146).

Multi-Sensor TTL metering and sophisticated fill flash modes make the SB-25 and SB-26 extremely versatile, basically insuring excellent exposures with the N90/F90 series cameras.

The N90/F90 camera with Nikon SB-25 Speedlight.

Page 121:
Top: Advanced Matrix metering produces beautifully exposed sunsets automatically.
Bottom: At moderate magnification as with a "macro" zoom lens (1/5 lifesize here) the f/5.6 aperture selected by the Close-Up Vari-Program offers adequate depth of field. At a higher magnification however, this situation would call for f/16 or f/22 to render the primary subject sharply.

Page 122:
Top: The Landscape Vari-Program selects an appropriate aperture for good depth of field, while Advanced Matrix metering produces accurate exposure in situations such as this.
Bottom: With a large area of bright sky in the picture, even Matrix metering can be fooled causing the foreground to be underexposed.

Page 123:
Ultra wide angle lenses (from 18mm to 24mm) are often used for landscape photography, especially with a small aperture for image sharpness from foreground to infinity. Advanced Matrix metering almost guarantees perfect exposure in circumstances such as those at the top. In more difficult exposure situations, such as the bottom photo, even the experienced photographer may bracket exposures to get one which is ideal.
Photos: Wolf Huber

Page 124:
Because the tiger will not stay still while you fiddle with camera controls, being able to shoot quickly is essential. An autofocus Nikkor lens, Advanced or 3D Matrix metering and a Program mode may be the best combination for capturing a moment which will not recur.
Photo: Herbert Mindl

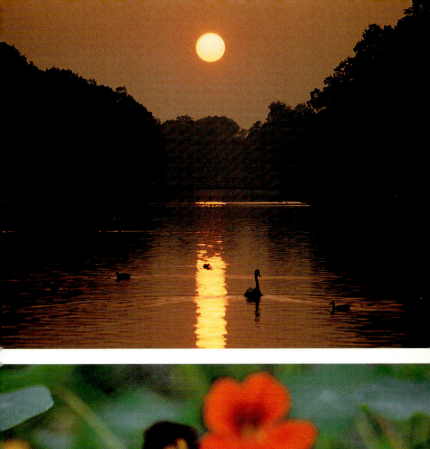

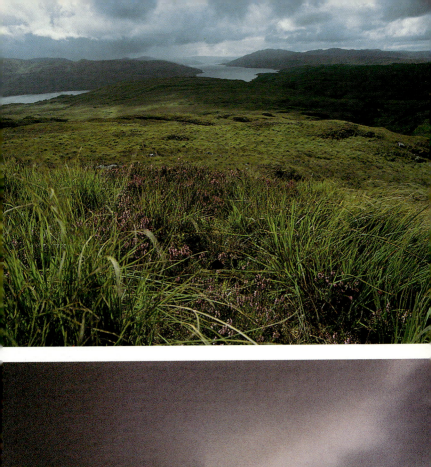

Page 125:
Because of the light-colored tombstone and the bright sky, the photographer used the AE-L feature to meter on an area that was 18% gray. With the exposure settings locked in, the picture was recomposed and the exposure was made.

Page 126:
Top: Even-illumination of both fore- and background resulted from an f/5.6 aperture and a shutter speed of 1/125 second, selected by the N90/F90's fill-flash and program mode, in conjunction with Matrix metering.
Bottom: For this photo, the flash was not balanced to the ambient light so the background remained dark. This is an excellent technique for making subjects stand out.

Page 127:
Top: Not all fisheye lenses produce a circular image on the square film frame. Those which are better corrected for linear distortion are more useful if you want to avoid a gimmicky look. (AF Nikkor 16mm f/2.8D)
Bottom: The twilight scene on Lake Geneva in Montreaux was captured quite well with a 24mm lens using Matrix metering.

Page 128:
Top: What appears to be popcorn on a stick is really bear grass in the Montana Rockies captured by a 20mm f/2.8 AF.
Bottom: The fleet's in, but separating the boats from all of the activity requires the isolating power of the 300mm f/2.8 N AF.

The SB-25's and SB-26's LCD panel relays relevant information, including the flash mode, minimum and maximum distance coverage, and necessary aperture (in manual modes). It can be illuminated for low-light situations.

Nikon's external battery packs SD-8 and SD-7 can be connected to the SB-25 or SB-26. There is also a new accessory, the SK-6 Power Bracket which attaches to the tripod socket of the camera to hold the Speedlight beside the body. These accessories, as well as battery packs from other manufacturers, can power the flash unit longer than alkaline or NiCd batteries and shorten recycle times.

Overload warning: The SB-25 and SB-26 are prone to occasional overloads. When this happens, the flash unit cannot be switched from TTL to M. Turn the power off on both the camera and flash unit and take the flash off the camera. Remove the batteries from the flash unit for a few minutes. Afterwards, everything usually will work normally.

Overview of Basic Flash Features

Before we cover the many exposure options offered by the Nikon flash system, we will explain the basic operational features of the SB-25 and SB-26 flash units.

The LCD Panel
The SB-25 and SB-26 flash units have an LCD panel that indicates all functions of the flash unit. These include: flash distances or ranges for a given f/stop, aperture in use (if using a lens with a CPU), automatic and standard TTL function and exposure compensation. In addition, it relays the operating status of the SB-25 or SB-26, ranging from the type of automatic flash or special flash functions, to the zoom head setting, is indicated. This display of information is invaluable for proper operation and creative flash control.

Test Flash
It is possible to evaluate the exposure without actually taking a picture by using the test button. On most Nikon Speedlights, this is the glowing red light on the back of the flash unit. When it is

pressed, the flash fires and the flash unit's sensor evaluates the flash. However, it is not measured by the camera's more accurate TTL system. If the indicator on the flash illuminates after the test, the output is generally powerful enough for a TTL flash exposure.

Variable Illumination

The motor-driven zoom head of the SB-25 or SB-26 adjusts automatically for the focal length of the lens when used with the N90/F90 series cameras and a lens with a CPU. An additional built-in diffuser panel in the SB-25 increases the angle of illumination to cover a 20mm lens, and in the SB-26 to an 18mm lens.

The vertically tilting flash head can point down at -7° (the distance scale blinks as a reminder), permitting the angling of the flash for close-up photography. The head can also tilt up for a maximum bounce of 90° (causing the distance scale to disappear). In addition, the flash head can be pivoted, or swiveled on its horizontal axis by 270°. This facilitates bouncing the flash off the ceiling when shooting vertically or off walls for horizontal shots.

Red-eye Reduction and Monitor Preflash

With the N90s/F90X, the SB-25 and SB-26 use a visible preflash to assist in reducing red-eye. A series of imperceptible monitor preflashes provide the TTL Multi Sensor with information regarding reflectance of the subject for use with "D" lenses.

AF-illuminator

This assists focusing in low light situations with the N90s/F90X.

Camera Viewfinder Information

Automatic Flash Indicator: When the existing light is too low or the brightness level of a scene (based on the film sensitivity and the subject's reflectance) has an EV value of less than 10, the green flash diode in the viewfinder illuminates, telling you to use flash.

Automatic Fill-flash Indicator: If the subject contrast (frame center vs. background) is greater than 1 f/stop, the green flash diode in the viewfinder prompts you to use fill flash. With matrix meter-

ing, Multi-Sensor Balanced Fill Flash (explained on page 136) will generally produce excellent results.

Flash Status: When the flash unit is attached and turned on, an indicator will glow in the viewfinder. This indicator relays a variety of information, depending on the situation.

Readylight: If the flash symbol in the viewfinder glows red for at least 2 seconds, the flash is fully charged. However, when you are shooting a series of frames, the flash will often fire with each exposure even though it may not be fully recycled. The "ready" symbol appears when the flash is about 75% recycled. If you want to be certain it has reached 100% (especially important with distant subjects) wait until the soft whistling sound of the flash unit ceases.

Insufficient power: If the flash symbol blinks repeatedly or goes out altogether after an exposure, the flash was too weak to properly expose the photograph. You can remedy the situation by opening the lens to a wider aperture, (in "A" or "M" mode), switching to more sensitive (higher ISO number) film, or moving closer to the subject.

Poor contact: The flash diode will also blink if there is a bad connection between the flash unit and the camera. If this happens, take the flash unit off and remount it, being sure to tighten the securing ring.

Metering Modes With Flash

When using flash, a camera exposure metering mode must still be selected. With all autoflash modes, the camera metering method reads only the ambient light. The automatic TTL flash control occurs independently, after the shutter is released. It is measured by the slightly center-weighted TTL flash meter.

Matrix metering: Matrix metering measures ambient (existing) light and subject contrast most accurately for well-balanced exposures. It is generally the best choice, but is only available when using AF Nikkor lenses.

Center-weighted metering: This method does not measure the ambient light illumination as accurately as matrix metering. Generally, the ambient exposure will not be as nicely balanced. It is, however, the best choice when not using an AF Nikkor lens.

Spot metering: This option only makes sense when manually setting the exposure on a large subject. If the exposure is set on the camera so that a distant subject area is normally bright, use of the flash will lighten the foreground.

Flash Exposure Modes

TTL Flash with Program Mode

Nikon's TTL technology can only be utilized when using a Nikon Speedlight with TTL capability, such as the current SB models. The simplest way to use a flash with the N90s/F90X is to set the camera to "P", metering to matrix, and the Speedlight to TTL. The N90s/F90X will automatically select the appropriate aperture and shutter speed and will calibrate the flash. Major exposure errors are just about impossible.

Aperture and exposure ranges: The automatically selected aperture covers a range of f/4 to f/16. The camera selected shutter speed covers a range of 1/60 to 1/250 second. In SLOW mode, the exposure time can be as long as 30 seconds, depending on scene brightness.

Limits of the flash program mode: This is a fully automatic mode providing little user control. If you want to select specific apertures for depth of field considerations, you should use flash in conjunction with Aperture Priority mode. If you want to have a lighter or darker background with fill flash, you should manually control the process. (Nonetheless, you can dial in flash exposure compensation for the subject with the SB-25, SB-26 or any Speedlight if using the MF-26 back.)

Backlit shots: If you are photographing a friend in front of a bright ocean view, the N90s/F90X can brighten the subject without the use of flash through Advanced (or 3D) matrix metering. In these pictures, however, the overall exposure may still not be ideal

because the contrast is so great. You will likely have a subject which is still a bit too dark, and an ocean which is a bit washed out. This is because the range of brightness values is beyond the recording ability (latitude) of the film. Using an SB-25 or SB-26 to illuminate to subject will produce a bright subject in front of a nicely exposed ocean, with fully saturated colors in both.

Flash with Ambient Light: Natural light adds a certain ambiance to the image and should not be overpowered by flash. With the Nikon Automatic Multi-Sensor Balanced Fill Flash, both ambient exposure and flash output level are adjusted so the main subject and the background are "balanced" for a pleasing, natural look. If you want more (or less) flash lighting, simply dial in "+" or "-" flash compensation on an SB-25/26 or any Speedlight if you own the MF-26 back.

Flash with Aperture Priority Mode

In "A" mode, you can freely select the aperture to control depth of field while using flash.

Procedure: Set the camera to "A," metering to matrix, and the mounted Nikon Speedlight to TTL. Select an aperture on the lens ring, and the exposure time will be automatically set between 1/60 and 1/250 second, depending on the ambient light. The flash will be calibrated by TTL metering during exposure.

Aperture and exposure ranges: The preselectable aperture range covers f/1.4 to f/16 (we found f/32 is also possible with certain film sensitivities). Exposures up to 30 seconds are possible in the SLOW mode. This is useful especially in night shots when you want the subject and a brightly lit background rendered with a balanced exposure.

Flash with Shutter Priority Mode

In this mode, you can freely select any shutter speed from 1/250 to 30 seconds. However, the risk of blurring due to movement by the photographer or the subject does increase at 1/60 second and longer. In some cases you may want motion blur for aesthetic effect. Otherwise, we see no particular advantage to using flash with Shutter Priority AE. Even with stationary objects, you will

generally prefer to control the depth of field, making Aperture Priority AE more useful. However, Shutter Priority mode is useful to create motion blur effects or to ensure a fast shutter speed if there is a great deal of ambient light in a scene.

Procedure: Set the camera to "S," the metering system to matrix, and the mounted Nikon Speedlight to TTL. Using the Command Dial, select a shutter speed between 1/250 and 30 seconds. An appropriate aperture will be selected depending on the ambient light. The flash will be calibrated according to the TTL Multi Sensor metering system.

Aperture and exposure ranges: Any shutter speed as fast as 1/250 second can be selected. The automatically selected aperture technically covers a range between f/1 and f/16, although even f/32 is possible in extremely bright light with ISO 1000 film.

TTL Flash with Manual Exposure Mode
In this mode, you can freely set shutter speeds from 1/250 to 30 seconds (with the SB-25 or SB-26 up to 1/4000 second in FP High Speed Sync mode) and apertures between f/1.4 and f/32. You can control background versus foreground illumination depending on metering method and the position of the subject.

Procedure: Select exposure mode "M" with matrix, spot, or center-weighted metering mode. Set the Speedlight to "TTL". Using either the built-in or a handheld meter, select an exposure time from 1/250 to 30 seconds along with an appropriate aperture. The flash will be controlled by the TTL system during the exposure.

Manual Flash Operation
When using fully manual flash, the TTL system is deactivated and you have full control of both flash and camera operation. The downside is that you must be experienced enough to calculate the correct exposure.

Every flash unit has a guide number which differs at the various settings of a zoom head. An aperture, appropriate for the distance to the subject and the guide number, must be set. The only real advantage of fully manual flash is that all lenses and flash units (as long as they are compatible) can be used.

The following explanations apply only to dedicated Nikon Speedlights, and not to non-dedicated flash units or studio setups where various flash units with different outputs are used.

Procedure: Set the camera to manual exposure mode "M" and select a shutter speed of 1/250 second or longer. If you are using a Nikon flash, set the appropriate ISO and manual flash mode "M". By reading the flash unit's scale, determine the f/stop which corresponds to the shutter speed and subject distance. Set the lens' aperture accordingly and depress the shutter release button.

Since the guide numbers of various flash units vary and because the reflective properties of the subject play an important role in the final image, quality pictures taken using the guide number formula are few and far between. It is safer to work with a flash meter whether in a studio or "on location" or to bracket the exposure by changing the aperture. Because of the N90s/F90X's well-engineered flash automation system, we strongly recommend working in TTL mode whenever possible. Keep an eye on the analog display. If it shows "+" the background will be overexposed. If it indicates "-" it will be underexposed. Adjust the aperture or shutter speed unless intentionally striving for special effects.

TTL Flash with Non-AF Nikkors
While using AF lenses is the preferred method, it is possible to use manual focus lenses with Nikon's advanced Speedlights.

Procedure: Set the camera to aperture priority AE mode with either spot or center-weighted metering. Set the flash to TTL and the lens to the desired aperture. Ambient light will be considered and the automatic system will adjust the shutter speed and the TTL flash exposure.

TTL Multi-Sensor Flash
This is a totally automatic feature that requires no input from you. Regardless of the exposure and metering mode you have selected (matrix is preferred), Multi-Sensor Balanced Fill Flash is engaged. The only requirement is that you use AF or AF D-type Nikkor lenses.

With Multi-Sensor flash in Program mode and any camera

metering mode, the aperture and shutter speed are automatically set before the exposure according to the camera's meter reading. After the flash is triggered, the five-zone Multi-Sensor TTL flash metering system determines the correct flash output. This very accurate system compensates automatically for difficult subjects with unusual reflectance.

TTL Multi-Sensor with Monitor Preflash
This is another fully automatic feature, available only when using AF or AF D-type Nikkors in conjunction with Nikon's SB-25 and SB-26 flash units. The SB-25 or SB-26 fires a series of imperceptible preflashes enabling the system to assess subject reflectance in advance. With input from the AF system, it determines the position of the subject in the frame (perhaps off to the left). Flash output is then controlled by the corresponding flash metering segment, optimizing exposure for the primary subject. When using D-type lenses, the system automatically provides 3D Multi-Sensor Balanced Fill Flash. Distance information is integrated in the final computation, and the system determines the subject's location and controls the flash output accordingly.

3D Multi-Sensor with Monitor Preflash
The 3D feature (Distance Data Detection) is only available when using AF D-type Nikkors. The system works the same as in Multi-sensor TTL flash but using the 3D feature increases exposure accuracy especially in high contrast situations.

Exposure Compensation with Flash
The exposure of an image can be adjusted with the flash instead of the camera. When using the camera for exposure compensation, the entire exposure is affected. Both the foreground and background become brighter or darker.

With flash exposure compensation, on the other hand, the flash output can be changed without affecting the exposure of the background. Therefore, the illumination of the subject by flash can be increased or decreased without brightening or darkening the background.

Manual correction: Also called Flash Exposure Compensation, this is set on the Speedlight when using a Nikon SB-25 or SB-26.

With other flash units, you would need an MF-26 back, which includes this feature. Manually input compensation affects the flash output. It can be set from -3 EV to +1 EV. A "+" setting will increase flash output for a brighter subject while a "-" setting will produce extremely subtle fill flash. In outdoor shooting, we often dial in some "-" compensation (less than one stop) but this is based on subjective preference.

With the MF-26 back, you can also set Flash Exposure Bracketing. This will fire a series of frames at varying compensation levels, in pre-determined increments. It can be useful if you are unsure of the amount of flash which will effectively render the subject.

Limitations of Flash Automation

While Nikon's TTL system may seem to be foolproof, there are several things that you should keep in mind whenever using a flash unit in conjunction with the N90s/F90X.

Limits of Metering
As far as the ambient exposure reading is concerned, the same limitations apply whether or not flash is used with any metering mode.

Overexposure: If the distance to the subject is very small as compared to the guide number of the flash and film speed, the danger of overexposure is particularly great.

In aperture priority or manual mode, the only solution is to stop down the lens (perhaps to f/16 or f/22) or use a slower film (lower ISO number). As an alternative, you can use a neutral density filter in front of the flash unit. As a last resort, you can use white facial tissue, typewriter paper, or any other thin white paper in front of the flash head to reduce the flash output.

Underexposure: The possibility of underexposure exists if the subject distance is so great that the flash's total light output is inadequate. This maximum flash distance, which decreases with smaller apertures, corresponds to the range of the flash unit on a manual setting. Even the best flash system cannot produce more than "full flash." If the output is not enough, your options are to move closer

to the subject, use a faster film, or open the lens further in Aperture Priority AE or manual mode.

Unusual Reflectance
Problems can arise when using flash on subjects that have unusual reflective properties. A bride dressed in white standing in front of a white wall will appear too dark, and a black cat sitting on a black car seat will appear too light. To compensate for these discrepancies, set the camera and flash to "M" and manually compensate. In automatic, dial in some exposure compensation for the best results.

Note: With matrix metering and AF lenses, the system will provide some automatic correction, so this override may not be necessary. Experiment with a roll of slide film before shooting an important assignment.

Film Speeds and Aperture Range
In order for a flash picture to be properly exposed, the entire scene must fall into the effective range of the flash unit. This range, for any given flash, is dependent on the speed of the film being used and the maximum aperture of the lens.

Film: The N90s/F90X's flash modes can only be used with film speeds from ISO 25 to ISO 1000.

Aperture: Maximum aperture will vary with different lenses. Those with a wide maximum aperture provide the greatest distance range.

Correction Range: Setting normal exposure corrections has the same effect as using different film speeds. The N90s/F90X automatically changes the range of the exposure correction values depending on the circumstances.

Special Flash Functions

There are several photographic options that become possible when using the N90s/F90X in conjunction with a modern Nikon System Speedlight.

Controlling Background Brightness

Depending on the situation, you may or may not want the foreground and background to be equally lit. To separate the main subject from the background, it is sometimes advantageous to create a darker or lighter background.

Procedure: Using manual exposure mode, select a shutter speed appropriate for the lens' focal length and the situation (between 1/60 and 1/250 second). Read the main subject with spot or center-weighted metering and set the aperture as if you were not using a flash. By stopping down a few stops, you will achieve a darker background. The reverse is true if you open the diaphragm to wider apertures. Bracket exposures to achieve the desired result.

Foreground vs. Background: The respective brightness of foreground and background can be varied by changing the camera exposure compensation and flash exposure compensation in opposite directions. For example, set the camera to +1 EV and the flash to -1 EV. This will produce a brighter subject and darker background with correct overall exposure. Once again, bracket exposures using a variety of possible combinations to attain optimal results.

SLOW mode: A good alternative for subjects against dark backgrounds with little ambient light such as city lights at night. Since the light that is emitted by the flash decreases with the square of the distance, you will find that the background looks like a "black hole" if it is too far behind the subject. Another typical situation is

Ideally, fill flash should be so subtle as to be unnoticeable in most outdoor pictures. With the SB-25/26 (or with any Speedlight when using an MF-26 back), dial in some minus flash exposure compensation for the most natural look.

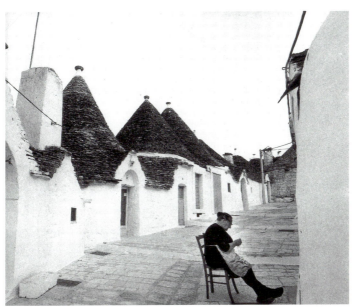

a large, dimly-lit room. With Matrix Balanced Fill Flash, the system will attempt to provide balanced illumination. In Manual flash, you may do so yourself. In either case, this may require a long exposure time, calling for a tripod and a remote shutter release to avoid blur.

Controlling Depth of Field
In principle, you can create a sharp or blurred background at will by simply changing the aperture in "A" or "M" modes. This is only possible, however, if the background is relatively close to the main subject (no more than twice the subject's distance from the camera). If it is too far, the light intensity falls off noticeably and a change of aperture affects not only the depth of field but also the brightness of the background. (In AE modes, the analog display scale will denote over- or underexposure of the background up to + or - 1 stop).

With long exposure times: First, set the aperture according to the desired depth of field. Set the exposure time according to the description above "controlling background brightness." A flower in a relatively dark forest would appear bright in front of a black background when using a large aperture such as f/4, and required shutter speeds of 1/60 or 1/250 second. Longer exposure times (as with f/16), on the other hand, result in a brighter background.

With extremely short (FP) exposure times: If you want to separate the subject from a relatively bright background by using a shallow depth of field, you need a wide aperture. With normal flash durations, however, the background will appear unnaturally bright because the flash will not sync at times faster than 1/250 second. However, with the FP function of the N90s/F90X with an SB-25 or SB-26, High Speed Sync is possible. Set the camera body to manual exposure mode, the flash to "M," and the "M" button to FP. Then, select the aperture appropriate for the depth of field you desire. Set a shutter speed, up to 1/4000 second, after taking a spot reading of the background. In FP mode, flash metering is non-TTL (using distance as the primary factor). Hence, you must strictly adhere to the distance range, as indicated by the SB-25 or 26's digital readout. This will be limited at the higher shutter speeds, unless using a high speed film!

Motion Blur Effects

Even with flash, you can carefully control motion effects. The sharp image created by the relatively short flash duration can be overlaid with blurred motion resulting from a long ambient exposure. This can lead to some very interesting effects.

Procedure: Set the N90s/F90X to shutter priority mode, the flash to TTL, and select a shutter speed corresponding to the blur effect you would like to achieve. Similar effects can be produced with weak ambient light in program mode and SLOW flash, or with manual exposure setting and long shutter speeds.

Example: Let's take a shutter speed of 1/8 second as an example. During the approximately 1/1000 second in which the flash is actually firing, only the flash's light output will be of consequence. During the rest of the long exposure, ambient light will expose the film. If your subject is in motion, a second, blurred image ("ghost image") will be recorded on the film. A similar effect results when the exposure is so long that the photographer moves creating a sharp image from the flash with a halo of movement around it. Without doubt, this is an area with a great deal of room for experimentation.

Second Curtain Sync: When using longer shutter speeds, with moving subjects, switch to "REAR" for second curtain sync. This means that the flash will be synchronized with the rear (or second) shutter curtain. In other words, the ambient light exposure is made first, before the flash is triggered. While conventional synchronization causes speed streaks ahead of the subject, this method produces streaks behind the moving object.

Put the camera into "S" or "M" mode and select a shutter speed that will give you the desired amount of blur. If you are using an SB-24, SB-25 or SB-26, select REAR synchronization on the flash unit itself. With other Speedlights, select it using the FLASH button on the N90s/F90X button cluster.

To Freeze Motion

A burst of flash can be used to freeze the motion of your subject. Everyone has seen the photograph of a bullet ripping through a playing card. This is the concept we'll consider here, though with slower speed subjects.

Procedure: Set the camera to "M" and shutter speed to "bulb." Adjust the lens to the desired aperture. With the flash unit set to TTL, shoot in near or complete darkness. The subject will be exposed during the relatively short flash duration.

With bright ambient light: If there is a good deal of light present and you wish to use fill flash on a fast moving object (perhaps a high jumper), you'll need very high speed sync to prevent a "ghost image". In this case, High Speed FP sync mode set to 1/500 second is required.

Set SB-25 or SB-26 to "M" and FP on the "M" button. Then select a shutter speed of up to 1/4000 second and an aperture that will yield the desired depth of field. Again, because the TTL system is disabled in FP mode, you must adhere to the distance range, as indicated on the flash unit's readout. This will guide your selection of f/stop and shutter speed, watch the distance range change on the scale with each new setting.

Stroboscopic Effects

The SB-24, SB-25 and SB-26 flash units have a repeating effect or "strobe" function which generates a series of very short flashes much like a strobe light. This will separate movement (perhaps a golfer's swing) into a series of sharp images on one frame of film. Strobe pictures enable the analysis of movements in sports and science, and produce pictures that are generally very interesting to look at.

Procedure: Set the N90s/F90X to manual exposure and select an appropriate shutter speed and aperture combination. Now set the main selector switch on the flash to strobe, indicated by three lightning bolts in a box. You must select the time between flashes (frequency) from 1 second to 1/50 second, the number of flashes (1 to 160), and the flash power from 1/1 to 1/64. Possible combinations depend on flash power.

For example, with 1/8 power and a frequency of 1-7 Hz, 20 flashes can be made in a row. With 1/64 power, 160 flashes are possible. Read the aperture indicated by the flash and set this on the lens. With a dark background and little ambient light, strobe images work very well.

Using Multiple TTL Flash Units

You can take automatic flash shots using several Nikon system flash units with the N90s/F90X. Multiple flash allows you to create sophisticated lighting, to lighten backgrounds, simulate backlighting, and a great deal more. Drastic exposure errors are virtually impossible, thanks to TTL automation.

Flash Combinations
There is a limit to the number of flash units that can be connected to the hot shoe with TTL cables because the camera's electronics can become overloaded. To help you to determine safe combinations, Nikon has assigned each system flash unit a numerical power rating. For instance, the SB-20 has a power rating of 9, the SB-22 is rated at 6, the SB-23 at 4, and the SB-24, 25 and 26 are rated at 1. The total system must not have a power rating greater than 20.

System Overload
If too many flash units are combined, you may not be able to release the shutter. To reset the camera, turn off and disconnect all flash units, reduce the number of units, reconnect them and then turn each on one at a time.

Accessories for Multiple Flash
There are relatively few accessories absolutely necessary for multiple flash photography. Besides the flash units themselves, you will need one TTL multi-flash adapter (AS-10) for each unit, one TTL flash shoe adapter cord (SC-17), and a few TTL extension cords (SC-18 or SC-19). If one of the units is mounted in the camera's hot shoe, however, the SC-17 cord is not necessary.

Helpful Hints
You must observe a few rules to assure simultaneous firing of each connected flash unit. The first rule is to use only Nikon System Speedlights; mixing units of various manufacturers can lead not only to misfiring but also to damage of the camera and the flash units.

Additionally, all flash units should have similar discharge characteristics. This does not apply, however, to Nikon Speedlights with different guide numbers. In reality, guide numbers make no difference as long as you use the highest power unit as the main

light. The SB-23, for instance, is a good choice for a main flash, but not as an auxiliary flash unit. It is logical that the less powerful units should be used to illuminate the background, or as fill and accent lights. Keep in mind, however, that the metering system reads the ambient light before the flash. Since the additional flash units illuminate the background, rendering this reading useless, expose manually using a handheld flash meter for the most predictable results.

SB-26 Wireless Remote Operation
The primary difference between the SB-25 and the SB-26 is the capacity to use the latter in Wireless Remote mode. The SB-26 contains a light sensor which detects the main flash unit's burst and fires the flash. It can be automatically triggered by a Speedlight attached to most Nikon cameras. Also referred to as "Slave Flash", this can eliminate a tangle of cables between the camera and remote flash units.

When used in Wireless mode, light output of the remote flash units is non-TTL. Instead, a sensor on the remote SB-26, not the camera's metering system, measures the distance to the subject and controls flash output. (You do need to set the f/stop on the remote SB-26 for each shot, use a smaller aperture than on the lens for gentle fill flash). In preliminary tests this worked quite nicely with an SB-26 attached to the hot shoe of the N90s/F90X and another SB-26 some distance away, closer to the subject. As long as the flash-to-subject distance was within the range denoted on the scale of the remote unit, there was no exposure error.

This was especially true when "Delay" mode was set on both SB-26 flash units. This is accessed by flipping a switch on the front to "D". Because of this, the wireless remote unit fired a split second after the "master" Speedlight, preventing underexposure of the subject. Because the light from the camera-mounted SB-26 is still metered through the lens (TTL), simultaneous firing can adversely affect exposure accuracy. With fully Manual operation however, Delay mode is unnecessary.

Fill flash was used to supplement the light from a window for this photo of an antique fire truck.

You can use any number of wireless remote SB-26s, even combined with up to five other Speedlights which are connected to the camera with the SC-18 and SC-19 TTL cables. You can set all to non-TTL "A" mode, or use a combination of TTL metering for the "hard-wired" Speedlights and non-TTL for the wireless remote SB-26's.

Our verdict on Wireless Remote Operation is this: We never really found the SC cables to be an annoyance unless working with numerous Speedlights. Since very few photographers use more than two, we predict that wireless mode will not be frequently needed. This is true especially with modern cameras like the N90s/F90X with its exceptional Multi-Sensor TTL Metering which produces more predictable and consistently pleasing results. However, this new capability will keep Nikon competitive with those other brands which already offered wireless remote flash capability.

Flash Accessories

Nikon Accessory Cords and Adapters

SC-17 TTL Remote Cord

One end of this 4.9' (1.5 m) coiled cable has a flash connector which slides into the flash shoe on the camera. It relays information between the camera and flash. The other side of the cable has a flash shoe and two multi-flash sockets for attaching any Nikon system flash unit or the connection of additional flash units via additional TTL cables (SC-18 or SC-19). With N90/F90 series

TTL Remote Cord SC-17

cameras, the SC-17 allows all TTL flash functions with all camera-specific options The SC-17 is necessary for using the flash off-camera or in conjunction with a flash bracket such as "Strobo-frame".

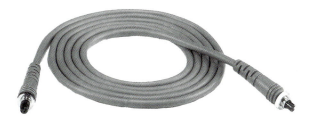

TTL Multiflash Sync Cord SC-18

Multiflash Sync Cords
TTL extension cables SC-18 and SC-19 are also called "TTL-Multi-flash-Cords." These feature connectors on both sides for Nikon multiflash system components (such as the SC-17 Cord, Multiflash Adapter AS-10, and Nikon systems flash units). They transmit all Nikon systems commands with all camera-specific options.

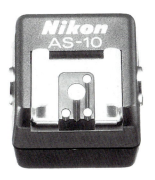

TTL-Multiflash Adapter AS-10.

TTL-Multiflash Adapter AS-10
For multiple flash with more than three flash units. One flash mounts directly on the AS-10's shoe, the rest are connected to its multiflash sockets using the SC-18 or SC-19 cord.

Stroboframe® Flash Brackets

Most people prefer the results from off-camera flash with a professional flash bracket such as those manufactured by Stroboframe® This is due to the fact that more natural-appearing illumination can be achieved by positioning the flash high above the lens. Light has a more natural effect (like sunlight) when it comes from the top. Flash units mounted directly on or next to the camera produce unflattering light with harsh shadows. With a bracket centered high over the lens harsh shadows fall below and behind the subject. The red-eye phenomenon becomes more pronounced the closer the flash head is to the optical axis. This problem is also solved by using a bracket which positions the flash unit high above the camera.

Stroboframe offers flash brackets and adapter plates for use on the Nikon N90s/F90X. One innovative feature is that the bracket position the flash unit above the camera even when the camera position is changed for vertical and horizontal formats. All Stroboframe flash brackets accept a shoe-style flash mount to accommodate Nikon system flash units and accessories. The screw which attaches the flashmount to the bracket is also compatible with the 1/4"-20 threaded hole on an SC-17 dedicated cord. Stroboframe also offers a Flash Quick Release to easily remove the flash from the bracket. This gives the photographer greater control over lighting.

Stroboframe makes several accessories for attaching the camera to the bracket. The Camera Auto Quick Release can be used between the camera and bracket, allowing them to be separated instantly. It can also be used between a camera and tripod. Anti-twist plates do just what the name implies, they register the camera and prevent it from twisting on the bracket.

System 2000 Flash Brackets
These are particularly compact in design and intended for diverse applications. The *RL2000 Rotary Link Flash Bracket* consists of a patented movable camera plate which allows an instant adjustment of the camera to horizontal or vertical format, while the flash unit's position remains unchanged.

Pro-T Bracket
The Pro-T bracket is simpler and more compact than the System

2000 series. Rather than use a camera rotating mechanism, the Pro-T has a pivoting flash arm to center the flash over the lens when the camera is turned vertically. It is an excellent bracket for cameras such as the N90s/F90X as it allows the photographer to hold the camera as though no bracket were attached while still offering optimum flash positioning.

Final Advice

There is a lot of material in these few brief pages on the theory of flash. Using flash successfully really requires understanding the nuances of flash and ambient light exposure. There is a lot more that can be learned about using the Nikon N90s/F90X with flash that will aid you in this quest. There are special effects that, with knowledge of flash, can be programmed into the camera and flash computers; these will allow you to take dramatic photographs without all the calculations. To arrive at this point and be able to apply these effects requires understanding the points we've discussed and practicing them until they become second nature.

The N90s/F90X and the flash units we have discussed, are computer systems packed with electronics. Unlike computers at home, however, a camera system is not grounded, and can be susceptible to static electricity. If the N90s/F90X locks up or functions erratically, don't panic. First try just turning the camera off and on. If that does not clear things, take all the batteries out of the camera, wait a few minutes and replace them. This seemingly simple solution can often clear problems and poses no risk to the camera.

If the camera fails to function as expected, don't tamper with it! Take it to a qualified Nikon dealer. In the event that it requires repair, this dealer can assist you in sending the camera to an authorized Nikon service center. If the camera is within the manufacturer's warranty period, proof of purchase is required, so bring a copy of your receipt with you.

Programming the N90s/F90X

The N90s/F90X comes out of the box programmed with 15 default functions. These functions can be adjusted when using the camera, but when the N90s/F90X is reset, it reverts back to these pre-programmed defaults.

Reprogramming

Many of the N90s/F90X's functions can be reprogrammed by authorized Nikon service centers (or through use of the AC-1E/2E card with Data Link). The following is a list of reprogrammable functions:

1) Individual program curves, by entering three distinct points on the curve.
2) Signal (warning) beeper's tone on N90/F90.
3) DX priority for film speed selection.
4) Optional simultaneous lock of AE and AF.
5) Automatic film rewind at the end of the roll.
6) Camera's time-out (between 4 and 60 seconds).
7) Continuous focusing during film transport in "S" mode.
8) Function of the AF-L button.
9) Long time exposures.
10) Exposure delay when using several cameras.
11) The data that is printed on the frame.

Additionally, there are several functions which are only available on the N90/F90 series cameras when using the MF-26 Multi-Control Back.

MF-26 Multi-Control Back

The MF-26 Multi-Control back can add a new dimension to your photography. It is a powerful tool that opens up a number of photographic possibilities. Remember that the main functions of the MF-26 are to print data right onto the film and add functions to the camera. The biggest problem with data backs has always been the

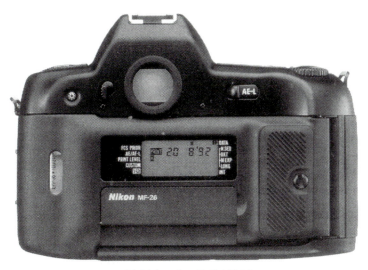

Multi-function Back MF-26

programming of their functions to operate when desired. This write-up is not intended to replace the instruction book, but further illustrate confusing points and make programming and operation simpler. Referring to the N90s/F90X and MF-26 instruction books should help to clarify attaching of the back and basic operations such as installing batteries.

Data Back Use and Operation

To access functions on the MF-26, the Command Dial on the N90s/F90X must be used in concert with the "FUNCTION" button on the MF-26. The following functions can be accessed in this manner in the following order: 1) Imprinted Data, 2) Auto-sequencing/all mode exposure bracketing/multiple exposure/long exposure, 3) Interval timer, 4) Focus priority, 5) AE/AF-Lock, 6) Print level, 7) Custom reset, 8) Flash output compensation. A small black bar will move around the LCD of the MF-26 aligning itself with the function selected; this appears in white letters next to the LCD window. Other readouts may appear on the LCD depending on the function selected. Other buttons such as "MODE", "SELECT" and "ADJUST" are also used with the Command Dial to alter and program the various functions. Be sure the camera is

turned on whenever programming the MF-26. And remember that many of these functions can also be set by using the Sharp Wizard EO and AC-1E (N90/F90) and AC-2E (N90s/F90X) cards.

Setting the Date and Time: This is one of the first functions to be set on the MF-26. Many of the other functions on the MF-26 directly rely on the correct date and time to operate. Press the "FUNCTION" button and turn the Command Dial until the black bar appears opposite the word DATA in the top right corner of the LCD panel. Press the "MODE" button and turn the Command Dial until the date appears in the format desired. The format options are Year/Month/Day, Month/Day/Year or Day/Month/Year. Now press "SELECT" and turn the Command Dial until the number that is to be changed starts blinking. With the number blinking, press "ADJUST" and turn the Command Dial until the desired number appears on the LCD. Go through this same procedure to change each number that is to be altered. To finish any one selection, press "SELECT" again and turn the Command Dial until the number no longer blinks which sets the change.

Setting the time: This follows the same procedures. With the black bar still next to the word DATA, press the "MODE" button and turn the Command Dial until the time appears on the LCD. There is only one format for the time, Day/Hour/Minute. As with the date, then press "SELECT" to select the number to be changed. Then press "ADJUST" to change that number, using the Command Dial to select the numbers. To finish, press "SELECT" and turn the Command Dial until the selected number no longer blinks. These are functions that can be also set using the Sharp Wizard EO and AC-1E/2E Data Link.

Setting the frame count: This can be set with or without film in the camera. It can be set by first pressing "SELECT" and turning the Command Dial until the black bar is opposite the word DATA in the top right corner of the LCD. Press "MODE" and turn the Command Dial until the letters "FRM" appear on the LCD panel. If the camera had no film loaded, an "E" will appear above the "FRM." (If film is in the camera, the camera will automatically set the frame count to the correct number.) Press "ADJUST" and turn the Command Dial until the number of the frame, viewed on the

camera's film counter, appears. Then press "SELECT" and turn Command Dial until the number no longer blinks. This feature can be set with the Sharp Wizard EO and the AC-1E/2E Data Link.

The World Clock: This is one of the next things that should be set on the MF-26. A number of other functions depend on the clock to operate correctly. Press the "FUNCTION" button while turning the Command Dial until the black bar appears next to the DATA on the top right corner. With this accomplished, press the "MODE" button and turn the Command Dial until the word CITY appears on the LCD panel. Below the word CITY will appear a city code number (the codes are listed on the command button panel), press "SELECT" and turn the Command Dial which makes the number blink. Press "ADJUST" and turn the Command Dial until the desired city code number appears on the LCD. There is a means in which to program in Daylight Savings Time. This might be important if you're a world traveler and depend on the world clock for the correct time. This feature can be set with the Sharp Wizard EO and the AC-1E/2E Data Link.

Sequence Number: This feature gives you the option of having a unique number for each frame of film which is automatically increased by one each time the film advances. To set Sequence Number, press the "FUNCTION" button and turn the Command Dial until the black bar appears opposite the word DATA in the top right on the LCD. Press the "MODE" button and turn the Command Dial until the word UP appears on the LCD. Six zeros will also appear if nothing has been set for this function yet. Each of the six place holders are changed in the same manner, one at a time. Press the "SELECT" button and turn the Command Dial until the desired place holder is blinking. Press "ADJUST" and turn the Command Dial until the desired number appear. Press "SELECT" and turn the Command Dial until it no longer blinks to program the MF-26. This feature can be set with the Sharp Wizard EO and the AC-1E/2E Data Link.

If multiple exposures are made on a single frame of film, the frame count display on the N90s/F90X might differ from that on the MF-26. This is because the MF-26 frame counter increases by one every time the camera is fired. The camera's frame counter however, only changes when the film is advanced. Changing

batteries could also alter the frame count on the MF-26. The sequence number can count up to 99 99 99 before resetting back to 00 00 00.

The Fixed Number: This provides the option for each frame of film to have an identifying number that's the same for all. This can be any six digit number ranging from 00 00 00 to 99 99 99. This number does not change each time the shutter is released. To set, press "FUNCTION" button and turn Command Dial until the black bar is opposite the word DATA in the top right corner of the LCD. Press "MODE" and turn the Command Dial until the word FIX appears on the LCD. The 00 00 00 will appear and each numeral can be selected for change by pressing "SELECT" and turning the Command Dial until the number blinks. Press the "ADJUST" button and turn the Command Dial to change the number and then press "SELECT" and turn the Command Dial until the number no longer blinks. Creating a blank space is achieved by using the setting between 0 and 9. This feature can be set with the Sharp Wizard EO and the AC-1E/2E Data Link.

The Shutter Speed/Aperture: If desired, the shutter speed and aperture in use can always appear on the MF-26 LCD. Press the "FUNCTION" button and turn the Command Dial until the black bar appears opposite the word DATA in the top right corner of the LCD. Press the "MODE" button and turn the Command Dial until the message TIME F appears at the top of the LCD along with the Shutter Speed and Aperture. No other operations are required.

The Imprint Level Adjustment: This should be set before information is imprinted. In case you forgot, any information programmed into the MF-26 can be printed onto a frame of film. Press the "FUNCTION" button and turn the Command Dial until the black bar appears opposite the word PRINT LEVEL on the left middle of the LCD. Press the SET/RESET button causing either an A, L, M, H1 or H2 to appear. Press "SELECT" and turn the Command Dial until the desired setting appears or to switch the setting back to A. This feature can be set with the Sharp Wizard EO and the AC-1E/2E Data Link.

A is an automatic setting that selects the intensity of the imprinting light for the film in use in the camera. The other settings are

available for when special films might be in use that require more or less light to properly expose the data unto the film. When this has been activated by using any of the special light level options (everything but A), a black triangle will appear opposite the black bar next to IMPRINT LEVEL. This acts as a reminder that the level is not on automatic.

Data Imprinting: Imprinting is an important feature of the MF-26. The following data can be imprinted onto the film via the MF-26: date, time, frame count, sequence number, fixed number, shutter speed/aperture. The first thing to select is the mode that is to be imprinted on the film. This is done by pressing "FUNCTION" button and turning the Command Dial until the black bar is opposite the word DATA in the top right corner of the LCD. Next press "MODE" button and turn the Command Dial until the desired function appears on the LCD. Next press the "PRINT" button which causes the word PRINT to appear on the LCD and a black triangle to appear next to the black bar. Each time the camera is fired, the selected data will then be imprinted on the frame. To cancel printing, press the "PRINT" button, causing the word PRINT and the black triangle to disappear.

Note: Anytime the word PRINT is present on the LCD panel, be warned that the data is printing onto the film!

The Multi-Control Back: These functions of the MF-26 can add a new dimension to your photography. They can also solve photographic problems which cannot be solved any other way! The functions available are: Long Exposure, Auto-Sequencing, All Mode Exposure Bracketing, Flash Exposure Bracketing, Multiple Exposure, Interval Timer, Focus Priority, AE/AF-Lock, Custom Reset, Flash Output Compensation, Vari-Program. These separate functions can be combined to operate simultaneously as well. For any function to be programmed into the MF-26, the N90s/F90X must be turned on! These are functions which are operational in nature; the imprint feature does not apply.

Long Exposure: This feature permits exposures up to 99 hours, 59 minutes and 59 seconds in duration. (Don't you hate it when they just don't say one second less than 100 hours!) To program, first

set the camera to manual (M) exposure mode and the shutter speed to "bulb" (B). Press the "FUNCTION" button and turn the Command Dial until the four black bars appear opposite the words on the right side of the LCD. One of the bars will light up while the other three blink. Press the "MODE" button and turn the Command Dial until the black bar next to the word LONG lights up and is not blinking. Press the "SELECT" button and turn the Command Dial until the desired unit to be set is blinking. The LCD readout displays from left to right, hours, minutes and seconds. Press "ADJUST" and turn the Command Dial to set the desired time for the exposure.

Do the same for each of the three units of time until the desired time for the long exposure is set. To complete, press "SELECT" and turn the Command Dial until all the numerals light up and are not blinking. Note that this function can be programmed through the AC-1E/2E Data Link system.

To set into motion, make sure the camera is turned on and set to "bulb" (B). Press the "SET/RESET" button so the black triangle appears next to the black bar opposite LONG. Press the "START/STOP" button to begin the exposure. To stop the exposure before the set time, press the "SET/RESET" button.

Auto-Sequencing: In conjunction with the continuous film advance mode, this feature allows a set number of exposures (from 2 to 19) to be fired while the shutter release is held down. Set the film advance on the camera body to "CH" or "CL". Press the "FUNCTION" button and turn the Command Dial until four black bars light up the right side of the LCD. Press the "MODE" button and turn the Command Dial until the black bar next to N.SEQ is not blinking. Press the "SELECT" button and turn the Command Dial; the number that now appears on the LCD (next to the F) starts blinking. Press the "ADJUST" button and turn the Command Dial until the desired number of frames to be fired appears on the LCD. Press the "SELECT" button again and turn the Command Dial until the number does not blink to set the number. To engage, press the "SET/RESET" button so that the black triangle appears next to the word N.SEQ. (If another function is to be combined with this one, this is the time to set it.) To start the Auto-Sequencing, press the shutter release. You can interrupt the sequence by taking your finger off the shutter release or cancel it by pressing the "SET/RESET"

button so that the triangle disappears. This function can also be programmed through the AC-1E/2E Data Link system.

Note: *Auto-sequencing will operate in single frame advance, but the photographer must press the shutter release for each exposure.*

Interval Timer: This function operates with the Auto-Sequencing to fire up to 99 exposures (changing film three times with 36 exposure rolls, of course) for durations up to 99 hours, 59 minutes and 59 seconds. Combining the two functions make sense for this function. First, set the Auto Sequence, referring to the explanation above for that operation.

Press the "FUNCTION" button and turn the Command Dial until the black bar appears opposite the word INT on the right of the LCD. A message will appear on the LCD, ST TIME. Press "MODE" and turn the Command Dial until ST TIME and the info below it lights up. Press "SELECT" and turn the Command Dial until the day (which is the calendar date; that's why the date and time must be already programmed in) unit shown by "—" blinks. Press the "ADJUST" button and turn the Command Dial until the date the timer is to start appears. If the timer is to start immediately, leave the "—" on the LCD. Now set the hour and minute the timer is to start in the same manor. Press "SELECT" and turn the Command Dial until this setting no longer blinks to register.

Now press the "MODE" button and turn the Command Dial until the INT TIME and clock light up. Press the "SELECT" button and turn the Command Dial until the hour starts to blink. Set it in the same manner as the above settings were, repeated for each unit of time. This sets the interval between which the camera fires taking a photograph. Once that is accomplished, press the "MODE" button and turn the Command Dial until the TIME and FRM appear on the LCD. Press "SELECT" and turn the Command Dial until the number under TIME blinks. Press "ADJUST" and turn the Command Dial until the number of times the camera is to fire appears. Press "SELECT" and turn the Command Dial until it is not blinking to set.

The number above the word FRM will be the same as that just dialed in unless Auto Sequence has been combined with this function. In that case, the number just dialed in will be multiplied by the number dialed in with Auto Sequence and that new number

will appear above FRM. For example, if with Auto Sequence the function was programmed to fire exposing two frames each time and there are 18 times the camera is to fire, the number over FRM would be 36, 2 x 18. Press "SET/RESET" and turn the Command Dial until the black triangle appears next to INT. To start the Interval Timer, press the "START/STOP" button. If the time to start is set for immediate ("—") then the exposure starts then. Otherwise, the camera will not fire until the programmed time. To cancel, press "SET/RESET" to make the black triangle disappear. There are a number of parameters in which this function will and won't work. Consult the Instruction Manual for these parameters. Note that this function can be programmed through the AC-1E/2E Data Link system.

All Mode Exposure Bracketing: With this feature, bracketing can be performed with any of the N90s/F90X exposure modes. Any odd number of frames can be selected for this mode between 3 and 19. The amount of exposure compensation, from frame to frame, can vary from 0.3 to 2 stops. The amount of exposure compensation desired can limit the maximum number of frames possible. The following chart provides you with those combos and limitations.

Exposure Compensation Degree	Number of Frames You Can Set
0.3, 0.5, 0.7	3 to 19
1.0	3 to 17
1.3	3 to 13
1.5	3 to 11
1.7, 2.0	3 to 9

To program: Press the "FUNCTION" button and turn the Command Dial until the four black bars light up on the right. Then press the "MODE" button until the black bar next to the word BKT does not blink. The words STEP, AE and BKT will appear on the LCD. Press the "SELECT" button and turn the Command Dial until the frame number (to the left of the F) starts to blink. Press the "ADJUST" button and turn the Command Dial until the total number of frames in the bracketed sequence appears. Use the "SELECT"

button, the "ADJUST" button and the Command Dial to set the exposure compensation value in the same manner. Press the "SELECT" button and rotate the Command Dial until only the black bars on the LCD are blinking to set the function. Press the "SET/RESET" button so the black triangle appears next to the black bar by the word BKT. Pressing the shutter release begins the process. Setting the film advance to one of the Continuous modes will take the entire bracket sequence by holding the shutter release. To cancel, press the "SET/RESET" button so the black triangle disappears. This programming can be left in the MF-26 and activated at any time by simply pressing the "SET/RESET" button. Note that this function can also be programmed through the AC-1E/2E Data Link system.

Flash Exposure Bracketing: This function affects only the flash and not the exposure of the ambient light. A Nikon Speedlight must be attached to the camera, turned on and switched to TTL to make this work. Press the "FUNCTION" button and turn the Command Dial until the four black bars appear on the right of the LCD and then press "MODE" and turn the Command Dial until the black bar next to the word BKT lights up and the word STEP and BKT appear. Press the "SELECT" button and turn the Command Dial until the frame number starts to blink. Press the "ADJUST" button and turn the Command Dial to set the number of frames desired. Set the exposure compensation in the same manner. Press "SELECT" and turn the Command Dial until only the black bars on the LCD are blinking to set. Press "SET/RESET" so the black triangle appears next to the black bar; trip the shutter to take the exposures. To cancel, press the "START/STOP" button until the black triangle disappears. Note that this function can be programmed through the AC-1E/2E Data Link system.

Multiple Exposure: This function permits anywhere from 2 to 19 exposures on the same frame of film. (This number can be increased by "tricking" the camera.) Press the "FUNCTION" button and turn the Command Dial until the four black bars light up on the right of the LCD. Then press the "MODE" button and turn the Command Dial until the black bar next to the word MEXP is not blinking. Press the "SELECT button and turn the Command Dial until the number on the LCD blinks. Press the "ADJUST" but-

ton and turn the Command Dial until the desired number of frames to be shot appears. Press the "SELECT" button and turn the Command Dial until only the black bars are blinking. Press "SET/RESET" to the black triangle next to the word MEXP appears. Pressing the shutter release starts the process with the film advance in a continuous mode working the best. To cancel, press the "SET/RESET" button to make the black triangle disappear. Note that this function can be programmed through the AC-1E/2E Data Link system.

Before the film counter on the MF-26 reaches "1", following the above sequence can add more multiple exposures to those already set. For example, if 30 exposures on one frame is desired, set the 19 frames. Then, when the counter hits "1", set it again for 12 frames (remember the last frame of the first sequence was not fired). In this way, 30 exposures can be made on one frame.

Note: Remember, some exposure compensation to prevent over-exposure will probably needed whenever setting multiple exposures.

Focus Priority: This function locks up the firing of the camera so the shutter will open only when the subject is in focus, even in Continuous AF mode. Press the "FUNCTION" button and turn the Command Dial until the black bar appears next to the word FCS PRIOR. Press the "SET/RESET" button so the black triangle appears next to the black bar. Next, point the camera and compose the photograph, depressing the shutter release to focus. When the in-focus mark appears, the camera will fire. This can be used to fire the camera automatically when a subject enters the pre-focused zone: a bird reaching the nest, for example. Note that this function can be programmed through the AC-1E/2E Data Link system.

AE/AF-Lock: These functions can be combined so they operate at the same time. To set, press the "FUNCTION" button and turn the Command Dial until the black bar appears next to AE/AF-L on the left of the LCD. Press the "SET/RESET" button to position the black triangle next to the black bar. To cancel, press the "SET/RESET" button so the triangle disappears. Note that this function also can be programmed through the AC-1E/2E Data Link system.

Custom Reset: This function allows you to set your own special program of the features and settings you use most. These include Metering Mode, Exposure Mode, Film Advance Mode, Focus Area and Flash Mode. A Custom program is called up in the N90s/F90X by pressing the +/- and camera reset button simultaneously for a few seconds. First, set the camera so all the above modes are set exactly as you want. To select this function, press the "FUNCTION" button and turn the Command Dial until the black bar appears next to CUSTOM and CSTM appears on the LCD. Press "SET/RESET" so the black triangle appears next to the black bar. To cancel, press "SET/RESET" to make the black triangle disappear. Note that this function can be programmed through the AC-1E/2E Data Link system.

Flash Output Compensation: This allows you to control the amount of flash exposure compensation between -3.0 and +1.0 stops with TTL flash units. Make sure a Nikon Speedlight is attached and turned on before setting this function. Press "FUNCTION" and turn the Command Dial until the black bar appears next to the lightning bolt symbol in the lower left corner of the LCD. A lightning bolt and +/- will appear on the LCD itself as well as a number in the top right corner. Press the "SELECT" button and turn the Command Dial until the number starts to blink. Press "ADJUST" and turn the Command Dial to set the amount of compensation desired. Press the "SELECT" button and turn the Command Dial to make the number stop blinking to complete setting. Press the "SET/RESET" button to make the black triangle appear next to the black bar. To cancel, press the "SET/RESET" button to make the black triangle disappear. Note that this function can be programmed through the AC-1E/2E Data Link system.

The following functions can be combined: Data Imprint, Interval Timer, Focus Priority, AE/AF-Lock, Custom Reset and Flash Output. To these, only one of the following can be added: Auto-Sequence, All Mode Exposure Bracketing, Flash Exposure Bracketing, Multiple Exposure and Long Timer. Limitations to this are Long Time and Interval Timer cannot be combined. To combine, program the desired function making sure the black triangle is next to it before programming the next function. All those functions denoted with a black triangle when the camera is fired will be functioning.

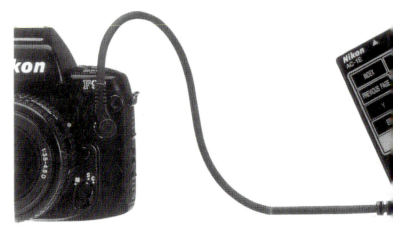

The Data Link System with IC card and electronic organizer.

Data Link AC-1E/2E System

Operating the N90/F90 or N90s/F90X through the Data Link System requires a Sharp Wizard Electronic Organizer (U.S.A.: #OZ-8000 or 9000 series; other countries: IQ-8000 or 9000 series) a Nikon AC-1E or AC-2E card and the MC-27 connecting cord. The AC-2E works with the N90s/F90X and the AC-1E with the N90/F90. With either, most of the workings of the N90s/F90X computer's system can be modified or enhanced according to your own personal photographic needs. This is the only camera system on the market that can be completely and totally personalized to one's own shooting requirements without having to go to the repair shop to have the modification performed.

Before we proceed, a note of caution: The data on the AC-1E/2E card can be modified, damaged or lost if care is not taken. To avoid loss of altered data, the following precautions should be observed. The battery for the AC-1E/2E card should be replaced every two years. When replacing the battery, make sure the AC-1E/2E card is installed in the Sharp EO. When inserting or removing the AC-1E/2E card from the Organizer, make sure the Organizer is turned off. A backup should be made of important data by either writing

it down or making a print out via the Organizer. And most importantly, read and understand completely the operations of the Electronic Organizer!

"Directly changing the setting(s) on the camera body while operating the AC-1E/2E card is not recommended. Doing so does not update the data in the AC-1E/2E card and may result in improper operation." This Instruction Manual warning should end with *"without pressing the COMMUNICATE key"*. Through much of the operation of various functions of the AC-1E/2E, manually setting the camera are required. If this is done, be sure to press the COMMUNICATE key to update the AC-1E/2E!

Operational Modes

Two modes, On-Line and Off-Line, are available with the AC-1E/2E. On-Line mode has five menus: Camera Operation, Customized Settings, Memo Holder, Photo Technique Selection and Control of MF-26 Multi-Control Back settings. Off-Line mode has three menus: Operations Guide, Photo Hand-Book and Utilities. It's the On-Line modes that are of the most use as they are used to customize the N90/F90 Series cameras. The following commen-

tary is in no way meant to replace the Instruction Manual. Instead, it should clarify some vague points and open up the possibility of functions useful to the photographer.

On-Line Mode

This mode offers a tremendous amount of programmability to the N90s/F90X user. When explaining each mode, I'll assume that the camera is plugged into the Sharp Wizard Electronic Organizer containing the appropriate AC-1E or AC-2E card. It is important to note that certain procedures outlined in the operation of the Sharp EO must be followed to avoid any errors. It is also important to beware of any messages or delays in the operation of the Sharp EO. For example, let's say the EO was turned off in the Card-Function mode. When reactivated, the AC-1E/2E's opening screen appears for a second; then the main menu appears on the LCD. Likewise, if the Electronic Organizer-Function was activated when the Sharp EO was used the last time, one needs to press the CARD key. The AC-1E/2E's opening screen appears for a second then the main menu will appear.

Activating the On-Line Mode: The LCD panel of the Sharp EO will communicate with you each step of the way, even telling you to connect the camera and Sharp EO using the MC-27 (if not done so already). To activate the On-Line mode, press the 1 key on the Sharp keyboard. Pressing HELP at this point brings up detailed information about each menu in the On-Line mode. With the camera turned on, press the ENTER/EXECUTE to relay camera information to the AC-1E/2E card. This transmits information such as exposure mode, aperture and shutter speed setting, lens in use etc. With this, the On-Line Mode menu appears with the following selections: 1. Camera Operation, 2. Customized Settings, 3. Memo Holder, 4. Photo Technique Selection, 5. Control of MF-26 Settings.

Note: The Photo Technique Selection cannot be used when the MF-26 is attached to the N90s/F90X nor can the Control of MF-26 be used when there is no MF-26 attached. At this point, press the number of the desired function. During AC-1E/2E communication, a < symbol blinks on the camera's LCD panel.

Camera Operation

This function duplicates functions one can do directly on the camera such as setting the shutter speed or firing the camera. The idea behind this function is to provide remote access to the operations of the camera when direct personal contact is not desired. Be sure not to change any of the N90s/F90X's functions directly on the camera while connected to the Sharp EO through the AC-1E/2E card. If this happens, none of the new settings are updated in the Sharp EO and may cause improper operation!

Pressing 1 brings up the Camera Operation menu. This provides control over 14 of the camera functions and confirms the camera's setting on the Sharp EO. Only a few of the options can be listed on the screen at any one time. Press the NEXT PAGE, PREVIOUS PAGE keys to view hidden options (an arrow in the lower left corner will indicate if there are more options either up or down from displayed options). Press the corresponding number for the operation desired. In some cases, an error message will appear and functions will cease to operate if incompatible camera and Sharp EO commands are attempted. These include the following: "Shutter Speed" is attempted when the camera's exposure mode is set to Program or Aperture-Priority mode, "Flash Sync" is tried with Vari-Program set on the camera, "Manual Film Speed Setting" is activated when the camera's film speed is set to DX, if "Starting Autofocus Operation" is tried with the camera's focus mode set for manual focus or when a non-AF lens is attached to the camera. To cancel the error message and return to normal operation, press ESC.

With the exception of "Starting Autofocus Operation," "Releasing Shutter" and "Camera Setting Confirmation," current camera setting are highlighted on the selected option. For example, if "Metering System" is selected and spot metering is set on the camera body, then when the three options appear on the LCD panel of the Sharp EO the spot metering will be highlighted. This can be changed by simply pressing the arrow keys until the desired metering mode is reached. Once the desired setting is highlighted, pressing COMMUNICATE will change the camera's mode from spot to Matrix. If no change is desired, then pressing ESC returns you to the main menu. This holds true for any of the different systems under the Camera Operation menu.

"Starting Autofocus Operation" is a basic function. Pressing the

ENTER/EXECUTE key tells the camera to focus. This will not happen: 1) if the camera cannot focus on the subject for reasons listed in the N90s/F90X Manual, 2)if the camera's focus mode is set to "M" (manual focus) or 3) if a non-AF lens is mounted or if an AF lens is set for manual focus. Because there are no options, there is nothing highlighted when this function is selected.

"Releasing Shutter" is another basic function in which there are no options to be highlighted when selected. Every time the ENTER/EXECUTE key is pressed, the camera fires. The camera will not fire in some cases: if film is not installed, if the film has not been advanced to frame 1, or if the camera shutter is set to bulb. If the camera does not fire and no error message appears on the Sharp EO LCD panel, return to the "Camera Operation" menu and select "Camera Setting Confirmation." Press HELP and the cause and remedy will appear on the LCD. If the shutter is locked because the camera is set for Focus Priority (and focus has not been achieved), then no message will appear. With models OZ-9600, OZ 9600II, IQ-9000 or IQ-9200, an error message will appear when shooting at shutter speeds 2 seconds or slower. Ignore this message as the shutter will be released.

The "Camera Settings Confirmation" offers no options; it just provides information of all that is going on with the camera. The Sharp EO LCD panel will communicate the following in either single letters, numbers or symbols: exposure mode, meter setting, flash sync mode, shutter speed, aperture, focus area and focus mode, Speedlight power on/off, film speed, film advance mode, film installation, number of stops from correct exposure (in Manual mode only), focus status, flash output level compensation, exposure compensation, frame counter, self-timer, lens focal length and maximum aperture (only with lenses with CPU) and battery symbol. So without ever looking at the N90s/F90X, you can know all this information and be in control of every function.

Customized Settings
Accessing Customized Setting requires pressing the 2 key which then presents three options: Custom Reset, User Custom Option and Custom Program. Now hold onto your hats, as this custom business can get tricky!

If you have made customized settings on your N90s/F90X through the camera commands, CUSTOM appears on the camera's

LCD panel: this means that you have selected modes other than the factory default settings. To reset the camera back to the factory defaults, press the +/- and 1 buttons for more than four seconds until CUSTOM starts blinking. Release the buttons and then press again within two seconds.

Custom Reset: can be accomplished and stored in the N90s/F90X by either adjusting the settings on the camera or with the Sharp EO. The metering system, exposure mode, film advance rate, focus area and flash sync that you use all the time can be entered into the camera's computer and called up by pressing the two reset buttons. To access this combination through the Sharp EO, press 1 from the Customized Setting menu. To confirm whether Custom Reset data is stored in your camera now, press 1. Setting the camera to desired settings and be stored as Custom Reset Data by pressing 2. And uploading a Custom Reset file from the AC-1E/2E card is accomplished by pressing 3. But #1 and #3 are only workable if you have customized the setting in same way which makes #2 important.

To activate Custom Reset Data, press 2. Then manually set the camera's metering system and other modes to desired settings and then press COMMUNICATE. Not mentioned in the instruction manual is the ability to store up to five Custom Reset Data files. Once made, these settings are stored on the AC-1E/2E card. The LCD panel of the Sharp EO now goes back the original menu offering the three custom options.

If the 1 key is pressed to confirm Custom Reset Data but none is present, an error message will appear on the LCD panel of the Sharp EO. And if Hyperfocal Program, Landscape Program or Silhouette Program is selected, the Sharp EO will flash an incorrect message of "(NORM)" for the flash sync. However, the N90s/F90X will display the correct Slow Sync setting which is what the camera is really set at.

What follows is information on creating or modifying Custom Reset files. From the Utilities menu, select 1 Custom Reset. Then press the correct key corresponding to the file desired. The LCD screen of the Sharp EO will then list all the settings for that particular file. To modify any of the settings, press the key corresponding to the item to be changed. This makes a menu appear with the options available for the mode. For example, Metering Mode pro-

169

vides three options: Matrix, Center-weighted and Spot. The mode that is currently selected for that file will be highlighted. To change, press the up or down arrow until the desired setting is highlighted. Then press ENTER/EXECUTE to save the setting and return to the main menu. If the option highlighted is one you want, and no changes are needed, press ESC to go back to main menu. At this point, a title can be given to the file. The title can have up to 31 characters but it is best to use short, one-word titles to remind you of the reason for those settings. For example, a file created for photographing landscapes with lots of depth-of-field might simply have a title of DOF.

Pressing 3, calls up the Upload Custom Reset file. On the LCD panel of the Sharp EO, the five Custom Reset Data files will appear. To select a desired Custom Reset file, press the number key corresponding to the correct file. If you've only created one Custom Reset Data file, then only one is available. The other four non-modified files have factory preset default settings. These files can be further customized or created, but must be done prior to this operation.

The LCD panel of the Sharp EO now displays all the settings for the Custom Reset Data file selected. If these are the correct settings, and the correct file designated, press COMMUNICATE. Now the file has been uploaded and stored in you camera. To retrieve stored settings in the camera, press the camera's two reset buttons for two seconds.

User Custom Option: Number 2 on the custom settings list is the User Custom Option. Pressing 2 from the Customized Settings Menu brings up a menu with three options: Current User Custom Option in Camera, Select Conditions for Each Function and Upload User Custom Option File. There are two methods in which a function can be modified. One is to select one option for a function, doing one function at a time (accessed by pressing #2). The other is to upload User Custom Option file from the AC-1E/2E card (accessed by pressing #3). These are the functions and the options available for each function with this menu.

To be able to upload Custom Option files, they must first be created. This is done by selecting the "2 User Custom Option" from the Utilities menu. Five files appear on the LCD panel of the Sharp EO, C1 through C5. These files will have the factory preset

User Custom Option Menu	Your Option
Continuous Beep for Picture Blur Alert	Activate* / Cancel
Double Beep for In-Focus Signal	Activate* / Cancel
DX-Priority	Set / Cancel*
Simultaneous Lock of AF and AE	Set / Cancel*
Time Delay for Auto Meter Switch-Off	4/8*/16/30/60
Focus Priority for Continuous Servo AF	Set / Cancel*
Release Priority for Single Servo AF	Set / Cancel*
AF Operation in Continuous Shooting	Activate* / Cancel
Program / Counter Viewfinder Display	Program mode* / Frame Counter
Long Time Exposure Selection	Bulb* / Time
Release Timing for Second Camera	Independent*/ Simultaneous / Alternative/Disconnect
Data Imprinting on Frame #0	Set / Cancel*

* Selected as factory set, refer to main text for further definitions of all these functions.

options listed above until they are modified by you. Press the number corresponding with the file to be selected. When in these files, up or down areas on the LCD panel of the Sharp EO indicate more pages are present with functions/options.

To modify the contents of any one function, press EDIT. You can select from the 12 functions listed above by pressing the number corresponding with the function to be modified. Once a function is selected, it will appear on the LCD panel of the Sharp EO

along with the option currently in use highlighted. This can be kept by pressing ESC or changed using the left and right arrow. Once a new option has been selected for that function and is highlighted, press ENTER/EXECUTE to retain. At this point, the LCD panel of the Sharp EO goes back to the functions menu. A title can be added to the file for easy reference later on by going to the 3rd item on page 3 of the User Custom Option menu.

Installing a Custom Option file into the N90s/F90X is accessed by pressing "3 Upload User Custom Option File" from the User Custom Option menu. The five Custom Option files, C1 through C5, appear on the LCD panel of the Sharp EO. Select the desired file by pressing the corresponding number key. The file contents will appear which can be confirmed visually and then press COMMUNICATE which customizes the N90s/F90X settings. After this is done, the LCD panel on the Sharp EO returns to the User Custom Option menu.

Custom Program: This is the last option on the Customized Settings menu. If you have already created custom files and know what they contain and they need no modifications, then this is the quickest way of getting a file loaded into the N90s/F90X. You can load one Custom Program file at a time from AC-1E/2E card into the N90s/F90X. Any custom program in the camera will be replaced with the newly loaded program. When a custom program is loaded into the N90s/F90X, the symbol "[P]" is automatically added to the camera's LCD and both P and M appear in the exposure mode window.

Custom Program Options: The Custom Program menu provides three options. Current Custom Program in Camera, Upload Custom Program File and Delete Custom Program from Camera. These are accessed by pressing the number corresponding with the desired option. If 1 is pressed and no custom program is operating in the camera, a message will appear stating so. If there is a program loaded, its contents will appear on the LCD panel of the Sharp EO. Each program contains a program line that consists of three points. These can be modified to create your own custom line.

From the Utilities menu, press "3 Custom Program" to modify the three points on the program line. Five files come up on the

LCD panel of the Sharp EO, CP1 through CP5. Select the desired file by pressing the number corresponding to that file. When this is done, the file and the program line appear on the LCD panel of the Sharp EO. To modify, press EDIT. If these files have not been previously modified, they will show the factory settings of A(f/1.4 60), B(f/2.8 60) and C(f/22 500). The program line is made according to these three settings or points.

Pick the first point to be modified and press the corresponding number key. A should now be highlighted allowing the up, down, left and right arrow to be pressed, changing the value for A. The left arrow makes the shutter speed go higher, the right arrow makes the shutter speed go lower, the up arrow opens up the aperture and the down arrow closes down the aperture. The program line cannot have an inward bent. Point A cannot be set to be located to the right or below point B. And point B cannot likewise be set to be located to the right or below point C. If this is attempted, for example Point A moved to the right of Point B, then point B will also move accordingly. After you have made your modifications and determined your program line, press ENTER/EXECUTE to save. To add or change the title assigned to this file, press 4 and enter a 31 character or shorter title. Press ENTER/EXECUTE to enter the title once it is typed.

Uploading a Custom Program file: Press 2 from the Custom Program menu. The five, CP1 through CP5 files appear on the LCD panel of the Sharp EO. Press the number corresponding to the file desired to be loaded; it will appear on the LCD panel of the Sharp EO. Confirm visually that it is the desired program line and then press COMMUNICATE which loads and stores the program into the N90s/F90X.

To delete a Custom Program from your camera, press "3 Delete Custom Program in Camera" from the Custom Program menu. Press Y and the file currently loaded in the camera will be deleted. The LCD on the Sharp EO will prompt you with a "Delete ? Y/N" to make sure this is what is desired. Once accomplished, a DELETED message will flash on the LCD of the Sharp and the symbol removed from the exposure mode window on the N90s/F90X.

Memo Holder
Selecting "3 Memo Holder" from the On-Line menu activates a

very useful system for the N90s/F90X. The Data Link System made up of the N90s/F90X, Sharp EO and AC-1E/2E card, is capable of recording shooting data. Shutter Speed, Aperture, Metering System, Exposure Mode, Flash Sync, Lens Focal Length, Exposure Compensation (if any), Flash Exposure Compensation (if any) is first stored in the camera and then later down loaded to the AC-1E/2E card.

You can create one file or unit of data for each roll of film. These units or files can be assigned a number between D0001 to D9999. A roll of film can be designated with any film/file number but no two can be designated with the same number. The film/file number used for storing shooting data automatically increases by one each time a new roll is installed in the camera. It also increases each time "Data Imprint on Frame #0" (from Custom Option) is activated. This is true even if shooting data storage has been canceled.

There is a limit to the amount of shooting data that can be stored. This number depends on the data to be stored, the number of frames per roll and whether its stored in the N90s/F90X or AC-1E/2E card. In-camera storage with the maximum amount of info for a 36 exposure roll is 2 rolls, and for a 24 exposure roll it is 3. With a minimum amount of info, the number increases to 5 and 8 respectively. Inside the AC-1E/2E card, storage increases tremendously: with the maximum amount of info, 50 rolls of 36 exposure and 66 rolls of 24 exposure. With the minimum amount of information, data on 74 and 94 rolls respectively can be maintained. The N90s/F90X has an increased in-camera storage capacity to a maximum of 35 rolls. Now if memos are added to a roll's file, the overall number of files that can be stored is reduced. And if you shoot frame 37 on a 36 exposure roll, or frame 25 on a 24 exposure roll, the total number of rolls that can be stored is reduced. You cannot select "Memory Mode Setting" if data is already stored in the camera. The data in the camera needs to be deleted or down loaded to the AC-1E/2E card. You also cannot select "Memory Mode Setting" if the film counter has advanced to frame #1. Doing so will cause and error message to appear on the LCD panel of the Sharp EO.

To set Memory Mode: Select "1 Memory Mode Setting" from the Memo Holder menu. Press either the up or down arrow to highlight "Store Shooting Data" and press ENTER/EXECUTE. To can-

cel, highlight "Cancel storage of shooting data", pressing ENTER/EXECUTE to enter. With this, the LCD panel of the Sharp EO will show "Storage of shooting data has been canceled." On the LCD panel of the Sharp EO is "Select Shooting Data to be Stored." A number of operating options are now on the screen which can be selected to be stored data. Press the left and right arrow to select the shooting data to be stored, then press COMMUNICATE. Once this is accomplished, the LCD panel of the Sharp EO will inform you how many rolls (for either 24 or 36 exposure) the memory will be able to store for the data requested. Part of making this all work is deciding before you start storing data what you're going to do if the camera's memory becomes full during shooting.

When the memory in the camera becomes full, "FUL" appears on the camera's LCD panel and the shutter of the camera locks. There are several ways to deal with this situation. Using the Sharp EO, select either "Stop storing data" or "Download stored data" and store the data on the AC-1E/2E card. Highlight the option you wish to use and then press COMMUNICATE prior to storing any data. Turning the camera on and then off deletes all stored data. The camera's shutter will remain locked until the memory is cleared. To resume data storage after deleting or downloading data, you must set Memory mode again. With this, the memory is in action and giving each roll of film a number. This number can be edited if so desired by pressing EDIT.

Downloading Stored Shooting Data: This is accomplished by first pressing "4 Data Loading" from Memo Holder menu. Downloading data is accomplished by pressing COMMUNICATE. This process deletes data from the camera's memory. If there is no data in the memory to be stored, an error message will appear on the LCD panel of the Sharp EO. If there is no more room on the AC-1E/2E card to store data, an error message will appear. In this case, go to the Utilities menu and select "Shooting Data" then delete unnecessary shooting data file(s) from the AC-1E/2E card.

The LCD panel of the Sharp EO shows "Processing information" during downloading, then displays the film files by roll number that were/are downloaded. This can only happen when the frame counter on the camera shows "E". This means nothing can be downloaded if the roll of film in the camera is partially shot.

175

Now if a roll of film must be removed from the camera without rewinding, press the camera's rewind buttons to reset counter to "E." If the shooting data should ever be damaged in some way such as by static electricity or electrical noise, the LCD panel of the Sharp EO will display a message stating damage. It then gives a "DELETE? Y/N" prompt. Press Y because pressing N cancels data deleting and the screen returns to the menu, however, the damaged data cannot be recovered.

Selecting "5 Data Deleting" prompts a message on the Sharp's LCD, "DELETE ? Y/N". Pressing Y deletes the stored shooting data of the previous roll of film from the N90s/F90X memory. The LCD panel then displays DELETED! and returns to the Memo Holder menu. Selecting "6 Data Clearing" deletes all shooting data from the N90s/F90X's memory. This operates the same as Data Deleting. Be careful not to confuse the two functions.

Photo Technique Selection
This is accessed by pressing the 4 key from the On-Line menu. The Photo Technique Selection on the AC-1E/2E card lets you perform some of the same functions as the MF-26, but not while the MF-26 is attached to the camera. Selecting the Photo Technique Selection with the MF-26 attached will cause an error. With the Photo Technique Selection function set, even if the Sharp EO is disconnected, the < will blink in the camera's LCD. This will happen while the camera's exposure meter is activated and will remain on even while the meter is off. Only when the camera's power is turned off will this disappear.

Under this menu, Focus Priority or Flash Output Compensation can be combined with Auto-Sequence Shooting, All Mode Exposure Bracketing, Flash Exposure Bracketing or Multiple Exposure Functions. If you attempt to select a function that is not compatible with a previously set function, the Sharp EO will ask if you're goofy (.... no, I'm kidding). The LCD panel of the Sharp EO will ask you whether you want to cancel the previously selected function that is set. Auto Sequence Shooting can be selected by pressing 1 from the Photo Technique Selections menu. Press the left or right arrow to select SET the press down arrow to set number of frames. Pressing the left or right arrow is required to set the number of frames. Press COMMUNICATE and the camera is set for Auto Sequence Shooting. When the camera's film advance is set

176

to Continuous Film Advance, the camera will fire off the number of frames set with this function, when the shutter release is depressed and held down. This is canceled by either turning off the camera or selecting cancel from the menu and pressing COMMUNICATE.

All Mode Exposure Bracketing is selected by pressing the 2 key from the Photo Technique Selection menu. Press the left or right arrow to select "Set" for All Mode Exposure Bracketing. Next, use the down arrow to highlight the amount of compensation desired. In the same fashion, set the number of frames to be taken using any odd number from 3 to 19. Press COMMUNICATE to transmit information to the camera. If the camera is set to "bulb" (B), this function will not work.

When selecting compensation and number of frames to be fired, the following conditions must be meet for it to operate.

Exposure compensation degree	Number of frames you can set
0.3, 0.5, 0.7	3 to 19
1.0	3 to 17
1.3	3 to 13
1.5	3 to 11
1.7, 2.0	3 to 9

If an unsuitable number of frames is set, the compensation degree automatically changes to the nearest correct value. And if you set an unsuitable amount of compensation, the number of frames will automatically change to the nearest number of frames. With this set, the camera will fire off the correct number of frames to complete the bracketing. If the film advance is set to "S", then depressing the shutter release for each frame is required. With the film advance set to Continuous, the camera will fire off the set number of frames without interruption as long as the shutter release is depressed. The images in the bracketing series are made in this order: underexposed, correctly exposed and then overexposed frames. Turning off this feature requires either turning off the camera of selecting "Cancel" from the Sharp EO menu and then pressing COMMUNICATE.

177

There are certain limitations to this function. In Program, Shutter-Priority and Aperture-Priority Autoexposure mode, the shutter speed and aperture will vary during each exposure as the compensation is figured into the exposure calculations. This function will not affect any exposure compensation manually set in the camera. But if compensation is dialed into the camera manually, this program will set its bracketing value around that pre-set compensation. In this mode, the flash exposure is not affected. And if the film should reach the end of the roll before all the bracketing has been accomplished, the shutter will lock. Rewind the film, install an new roll and depress the shutter release to finish off the bracketing sequence.

Flash Exposure Bracketing: This works only with Nikon Speedlights in the TTL Auto flash mode. Select "3 Flash Exposure Bracketing" from the Photo Technique Selection menu to access this feature. Then press the left or right arrows to select "Set" and press the down arrow to highlight the "Select compensation degree." Now use the left or right arrow to set the desired amount of compensation. In this same fashion, set the number of frames to execute this bracketing from 3 to 19. Press COMMUNICATE to transmit this information to the camera. The number of frames and amount of compensation is the same as in the table for the previous function. Other than turning on the Speedlight, this then operates the same as the previous function. In any exposure mode, only the flash output is affected for any compensation that has been selected. Shutter speed and aperture are not changed to achieve compensation. To cancel, turn the camera off or select "Cancel" from the menu.

Multiple Exposures: This function can be set by selecting "4 Multiple Exposure" from the menu. Press either the left or right arrow to select "Set". Then press the down arrow to highlight the frame numbers. Use the left or right arrow to set the number of frames desired, from 2 to 19. Press COMMUNICATE and this information is set in the camera. By depressing the shutter release, the camera's shutter will fire off the pre-set number of frames onto just one frame of film. The shutter is opened each time but the film never advances. To cancel, turn the camera off or select "cancel" from the menu. More exposures can be taken on one frame as long as

you do so before the counter hits 0. Simply reprogram in the same way as setting the original number of frames. In this was, as many exposures as desired can be taken in groups of 18 or less.

Flash Output Compensation: This works only with Nikon Speed-lights in the TTL auto flash mode. This is selected by pressing "5 Flash Output Compensation." Press either the left or right arrow to select "Set" and then press the down arrow to highlight the compensation. Press either the left or right arrow to set the amount of flash output compensation desired and then press COMMUNI-CATE to transmit to the camera. The values the flash can be set are in 1/3 stop increments ranging from -3.0 to +1.0. Firing the camera now will expose the film with the flash's exposure altered by the amount of compensation set. To cancel, turn the camera off or select "Cancel" from the menu.

Focus Priority: This is selected by pressing "6 Focus Priority" then pressing either the right or left arrow to highlight "Set." Then press COMMUNICATE and the camera is set. To cancel, turn the camera off or select "Cancel" from the menu.

Control of the MF-26 Settings

This can be achieved by first selecting "5 Control of MF-26 Settings" from the On-Line menu. This function cannot be selected if the MF-26 is not attached to the N90s/F90X. For details on operating the MF-26, either refer to the MF-26 section in this book or the Instruction Manual that comes with the back. Many of these functions are operational on the camera just as previously described by the same heading in the prior text. A number of MF-26 functions can be performed by the Sharp EO without the MF-26 as described in the appropriate heading/title.

Uploading Date and Time: Uploading data from the Sharp EO to the MF-26 is accomplished by first selecting "1 Date and Time" from the Control of the MF-26 menu. Simply press 1 to upload the date and time from the Sharp EO to the MF-26. The Sharp EO LCD panel shows the date and time set on the Sharp EO. There is also an option for daylight savings time which can be selected by pressing the left arrow to highlight "Yes." Pressing COMMUNICATE will upload all this information to the MF-26. City code number

can also be changed under this menu. Press 2 to check or modify the city code number and if changing, use the up or down arrow to change the code. Press COMMUNICATE to enter this change. The MF-26's world clock uses one-hour increments where the Sharp EO works on half-hour increments differences from GMT. Changing the city code on the MF-26 after the date and time have been uploaded from the Sharp EO may cause a difference in time.

Data Imprinting: This is accessed by selecting "2 Imprint Data" from the Control of MF-26 Settings menu. The Imprinted Data menu then appears on the LCD of the Sharp EO providing five options. Selecting Imprinted Data can be accessed by pressing 1. There are eight forms of the data that can be imprinted, Year/Month/Day, Month/Day/Year, Day/Month/Year Day/Hour/Minute, Frame Number, Sequence Number, Fixed Number and Shutter Speed/Aperture. Press the up or down arrow to highlight the desired form and them press COMMUNICATE to download to the MF-26.

Imprinting with the MF-26: This is activated by pressing "2 Imprint/No Imprint." Press the up or down arrow to highlight your choice then press COMMUNICATE to set the selection.

Adjusting the Imprint level can be important if using a special film, or when you desire a brighter to darker imprint image. Select "3 Imprint Level Adjustment" from the menu. The current imprint level is highlighted. The options available are A (Auto) which is the default, L ISO 25, M ISO 32-100, H1 125-400 and H2 (refer to MF-26 section for special films recommendations). Press the up or down arrow to highlight the desired setting and then press COMMUNICATE to enter.

Sequence Number Setting: This is activated by pressing "4 Sequence Number Setting" from the menu. To change the number, press EDIT. Use the number keys to input any six digit number between 000000 and 999999 and then press COMMUNICATE to enter.

Fixed Number Setting: Setting a fixed number is activated by pressing "5 Fixed Number Setting" from the menu. To change the number, press EDIT. Use the number keys to input and number desired between 000000 to 999999. Then press COMMUNICATE to enter.

An example of an exposure series using the auto bracket feature with a normal exposure (middle), 1/2 stop underexposure (top) and 1/2 stop overexposure (bottom).

Note: *To return to the menu without changing either the sequence or fixed number, press ESC.*

Photo Technique Selection: This is accessed by pressing "3 Photo Technique Selection" from the Control of MF-26 Settings menu. There are six options under this heading, Auto Sequence Shooting, All Mode Exposure Bracketing, Flash Exposure Bracketing, Multiple Exposure, Long Exposure and Interval Timer.

Auto Sequence Shooting: Selected this mode by pressing "1 Auto Sequence Shooting" from the Photo Technique menu. Press the left or right arrow to select "Set" to select the function. Next, use the down arrow to highlight the frame indicator and the right or left arrow to select the desired frames. Press COMMUNICATE to enter your selection into the MF-26. To turn off without using the MF-26's SET/RESET button, go to the "Auto Sequence Shooting" menu; select "Cancel" and then press COMMUNICATE.

All Mode Exposure Bracketing: This can be selected by choosing "2 All Mode Exposure Bracketing" from the Photo Technique menu. Press the left or right arrow to select "Set" for bracketing. Then use the down arrow to highlight the compensation degree and use the left or right arrow to set the amount of compensation desired. In this same way, set any odd number of frames between 3 and 19. Press COMMUNICATE to transfer information the MF-26. To turn off without using the MF-26's SET/RESET button, go to the "All Mode Exposure Bracketing " menu. Select "Cancel" and then press COMMUNICATE. Remember, if the camera is set to "bulb" (B), All Mode Exposure Bracketing will not function.

Flash Exposure Bracketing: This can be activated by pressing "3 Flash Exposure Bracketing" from the Photo Technique menu. Press the left or right arrow to select "Set" and then the down arrow to highlight the Select Compensation degree number. Press the left or right arrow to set the desired amount of compensation. In this same manner, set the number of frames to any odd number from 3 to 19. Press COMMUNICATE to set the MF-26. To turn off without using the MF-26's SET/RESET button, go to the "Flash Exposure Bracketing " menu. Select "Cancel" and then press COMMUNI-CATE.

Use the long exposure feature for photographs such as this one. A tripod and remote release are also useful. Photo: Paul Comon

Multiple Exposure: Activate by pressing "4 Multiple Exposure" from the menu. Press the left or right arrow to select "Set". Then, use the left or right arrow to select the number of frames from 2 to 19. Press COMMUNICATE to send this to the MF-26. To turn off without using the MF-26's SET/RESET button, go to the "Multiple Exposure " menu, select "Cancel" and then press COMMUNICATE.

Long Exposure: This can be activated by pressing "5 Long Time Exposure" from the menu. Press the left or right arrow to select "Set" and then press ENTER/EXECUTE. Another menu now appears that allows the time of the exposure to be entered. Press the left or right arrow to move the cursor and number keys to input the number desired. Unless the camera is set to "bulb" (B), Long Exposure cannot be set and if attempted, an error message will appear on the LCD panel of the Sharp EO. To turn off without using the MF-26's SET/RESET button, go to the "Long Time Exposure " menu, select "Cancel" and then press COMMUNICATE.

Interval Timer: This can be activated by pressing "6 Interval Timer" from the menu. Press the right or left arrow to select "Set" and then press ENTER/EXECUTE. The current setting will then appear for the Interval Timer, Start Time, interval time and other combined functions, total number of frames and total number of shootings. If any of these numbers are to be changed, press EDIT and change. If "Immediately" appears instead of a start time, then the day is set to "0" and the first frame will be taken as soon as the Interval Timer is activated. Press COMMUNICATE to call up next menu.

Selecting "Set" and then pressing ENTER/EXECUTE in this mode will automatically cancel some other features if set on the MF-26. Auto Sequence Shooting, All Exposure Bracketing, Flash Exposure Bracketing or Multiple Exposure will be canceled if Interval Timer is used. And because of this, a "No" will appear next to the "combined other functions."

You now have two options, "Taking first shot immediately" or "Setting start time." Setting the start time is done by pressing the left or right arrow and using the number keys to set a time. Afterwards, press ENTER/EXECUTE or press ENTER/EXECUTE if "Taking first shot immediately" is your choice. Either takes you to the

next menu. The interval time is set by pressing the left or right arrow and using the number keys. When set, press ENTER/EXE-CUTE.

The next option is the combining of function(s); press Y for yes or N for no. If yes is selected, then use the up or down arrow to the select the desired functions(s) to be combined. Once these are highlighted, press ENTER/EXECUTE. You will have to go through the menus and set all the parameters for each function that was selected to be combined with Interval Timer. Refer to earlier references for all functions if you wish to set these.

Once this is all accomplished, input the number of frames and the Interval Timer is ready to fire. Press either the left or right arrow to highlight the number to be changed and then use the number keys to make the change. Press ENTER/EXECUTE to enter. Finally, confirm everything and if all is correct, press COMMUNICATE to set the interval timer on the MF-26. To turn off without using the MF-26's SET/RESET button, go to the "Interval Timer" menu, select "Cancel" and then press COMMUNICATE.

Note: Interval Timer cannot be used if the camera is set to "bulb" (B); an error message will appear on the LCD panel of the Sharp EO.

Flash Output Compensation: This can be accessed by pressing "4 Flash Output Compensation" from the menu. Then press the left or right arrow to select "Set" and then the down arrow to highlight the compensation value. Use the left or right arrow to set the desired amount of compensation in 1/3 stop increments ranging from -3.0 to +1.0. Press COMMUNICATE to set this in the MF-26.

Customized Settings

These can be activated by pressing "5 Customized Settings" from the menu. There are three options: Simultaneous Lock of the AF and AE, Focus Priority and Custom Reset Settings.

Simultaneous Lock of AF and AE: This can be activated by pressing 1. Use the left or right arrow to select "Set" and then press COMMUNICATE to lock these two features together. To turn off , press the MF-26's SET/RESET button, or go to the "Simultaneous lock of AF and AE " menu, select "Cancel" and then press COM-MUNICATE.

Focus Priority: Activate this operation by pressing 2. Press the left or right arrow to select "Set" and then press COMMUNICATE to set Focus Priority. To turn off, press the MF-26's SET/RESET button, or go to the "Focus Priority" menu. Select "Cancel" and then press COMMUNICATE. Refer to the section on MF-26 for camera/back operation.

Custom Reset: Activate this operation by pressing 3. Press the left arrow to select "Y (Set)" and then press COMMUNICATE. This sets the Custom Reset on the MF-26. To retrieve the stored settings, press the camera's +/- and reset buttons simultaneously for two seconds. To turn off, press the MF-26's SET/RESET button, or go to the "Custom Reset" menu; select "Cancel" and then press COMMUNICATE.

Off-Line Mode
This mode can be used with or without the N90s/F90X being attached to the Sharp EO. There are three menus under this: Operations Guide, Photo Hand Book and Utilities. The first two are what you would expect: written guides that replace instruction books etc. Utilities on the other hand, directly works with files created On-Line and can be used to modify those files.

Operations Guide: Operations Guide consists of three sections, F90/N90 Camera Body, With Speedlight SB-25/26, and With Multi-Control Back MF-26. Each offer a number of headings and sub-headings that can be looked up for an explanation.

The operation and use of these menus is like all others in the Sharp EO. Press number keys to select the feature/function to be read about. Then use other keys as indicated by the Sharp EO to access other menus or information. This is a straight-forward program which enables a photographer to review or learn about how the N90s/F90X operates.

Photo Hand Book: This is another reference system containing two sections, "Photo Glossary" and "Photo Formula". Accessing and manipulating this is like any other menu drive program in the Sharp EO. There are numerous features/functions that are on the menu under this heading.

The Utilities menu: This is an extremely useful and important feature of the AC-1E/2E. Rather than list here and explain how it interacts with the On-Line software, each Utilities operation was explained with its appropriate On-Line function. The five options under this heading are: Custom Reset, User Custom Option, Custom Program, Shooting Data and Memory Check. The first four files can be found under their appropriate operations previously mentioned in the text. The Memory Check is a simple operation that when accessed (by pressing 5), provides information on how many rolls of Shooting Data that has been stored and how much of the AC-1E/2E storage space have been used in that storage.

The Verdict: With the Electronic Organizer, the N90/F90 series becomes the world's first truly remote-controlled cameras. While many functions are just as easily controlled on the camera body itself, the set up is ideal for photographic reproduction or research applications. It is difficult to say if such a sophisticated organizer is really needed. While its concepts and goals are grand, in practical operation, it is questionable if all its many functions could be utilized enough to make ownership worthwhile.

N90s/F90X Specifications

Camera type: Autofocus, 35mm single lens reflex with fully-electronic functions and features optimized for professional use.

Film format: 35mm; image size 24 x 36 mm.

Lens mount: Nikon F-bayonet with additional electronic control and data transmission contacts for AF lenses with integrated motor connections. Additional electronic transmission of the focus distance with D-type AF Nikkor lenses and use of the internal motors of the AF-I Nikkor lenses. Mechanical transmission of aperture with AI and AI-S Nikkor lenses.

Autofocus system: Passive, with TTL phase detection and a cross-shaped CAM 246 autofocus sensor module. Size of focus detection field is selectable from wide to narrow spot. Working range: EV -1 to EV 19 at ISO 100 with 50mm f/1.4 lens. Tracking autofocus in all AF modes. N90s/F90X has been updated with a new coreless focus drive motor and improved algorithms for faster autofocus operation.

Focus assist: Electronic rangefinder in viewfinder for manual focusing works with AF Nikkor lenses and most AI and AI-S Nikkor lenses that are f/5.6 or faster.

Metering modes: 1) Center-weighted metering (75/25 ratio). 2) Spot metering; in the center of the viewing screen, approximately 1% of the image area, range EV 3 to EV 21 (at ISO 100 and lens speed f/1.4). 3) Advanced Matrix metering, eight zones metered, range EV 1 to EV 21 (at ISO 100 and lens speed f/1.4). Automatic exposure correction. 4) 3D Matrix metering with D-type lenses, subject distance is incorporated in the exposure evaluation formula. (Same range as above).

Autoexposure (AE) modes: 1) Shutter priority ("S"). 2) Aperture priority ("A"). 3) Auto-Multi Program mode ("P") with usershift possible (Flexible Program).

Subject optimized Vari-programs: Seven options: 1) Portrait. 2) Portrait with flash and red-eye reducing preflash. 3) Silhouette. 4) Hyperfocal: extensive depth of field. 5) Landscape. 6) Sport. 7) Close-up.

Manual exposure mode: Aperture settings are on the lens, shutter speeds are on the Command Dial. The values are displayed in the viewfinder and on the external LCD panel. Relative brightness is displayed on a scale using 1/3 stops.

Exposure compensation: Manually selected from -5 EV to +5 EV in increments of 1/3 EV (1 EV= 1 f/stop or 1 shutter speed interval).

Automatic bracketing: Only available with the Data Back MF-26 or Data Link accessories.

Shutter: Electronically controlled, vertically traveling metal focal plane shutter made of a wear-resistant metal alloy.

Shutter speeds: Because of its lightweight design, this shutter is capable of speeds from 30 seconds to 1/8000 second. Speeds can be controlled in 1/3 stop increments. (Full stops with N90/F90). Common to all models are the "bulb" setting and stepless shutter speeds using the Aperture priority, Program or Vari-program modes.

Shutter release: Electro-mechanical with 3 functions: 1) Light touch activates exposure metering for approximately 8 seconds. 2) Pressing it half-way activates the autofocus and focus lock in AF mode "S". 3) Pressing it all the way activates the shutter. A separate camera power switch locks the shutter release. There is no mechanical cable release socket. Remote triggering is provided by the optional MC-20 cable release.

Self-timer: Electronic. Delay is adjustable from 2 seconds to 30 seconds and for one, or two shots in 10 second intervals. Countdown is shown by a blinking LED on the camera body. Cancellation is possible.

Multiple exposures: Only possible with the Data Back MF-26 or Data Link.

Viewfinder: Non-interchangeable, high-eyepoint viewfinder with eye relief up to 19 mm. 92% of the image is shown at a magnification of 0.78X (with a 50mm lens set at infinity). A built-in blind can be closed to prevent stray light from entering the viewfinder and causing incorrect exposure when the eye is not close to the eyepiece.

Focusing screen: Supplied with Brite-View screen "type B," interchangeable with cross-hatch "type E."

Viewfinder displays: Continuous after touching the shutter release button. Displays focus detection field size, focus indicator, exposure mode, shutter speed, aperture, frame counter, flash recommendation and flash status when using a dedicated Speedlight. When conditions warrant, viewfinder displays incorrect exposure warning, light metering analog scale (in Manual mode) or exposure correction advice, and end of film roll.

External LCD: 1) Constantly shown: Exposure mode, exposure metering mode, selected focus detection area, frame counter, film transport, and transport error warnings. 2) Shown for approximately 8 seconds after touching the shutter release: Exposure time (including B), under- or over-exposure warning, aperture (full stops only), AF mode, manual focusing (if selected), flash mode (excluding normal TTL), film loaded, film transport verification, battery test, Data Link connected, and user programmed functions (via Data Link). 3) Shown after touching appropriate function button: film speed, exposure correction factor, self-timer delay, and selected Vari-Program.

Warnings: 1) Aperture ring in "P" and "S" modes is not set to minimum; flash unit not set on TTL in "P" mode; under- and overexposure; use of non-AF lenses with inappropriate mode; Bulb exposure selection with inappropriate mode; camera shake (exposure times longer than 1/focal length in seconds) in "P" and "S" modes; film with erroneous or no DX code; and film transport problem. 2) Indicators: End of film, rewind complete, and self-timer progress. 3) OK: Focusing in AF "S" mode complete.

Film sensitivity: Automatic DX from ISO 25 to ISO 5000 or manual from ISO 6 to ISO 6400.

Film loading: Automatically advances to first frame when shutter release is fully depressed. Correct loading and film advance is verified on LCD panel.

Film transport: Motor-driven after each exposure, with three available modes: 1) Single Frame mode, "S." 2) Continuous exposure "L" (2 frames per second possible). 3) Continuous exposure "H" (3.6 frames per second with N90/F90 and 4.3 fps with N90s/F90X). Successful film transport is verified on LCD panel. Auto-stop at the end of the film.

Frame counter: Additive counter; also counts down as film is being rewound.

Film rewind: Motorized; film leader is pulled into cassette, but can be reprogrammed by Nikon Service to leave the leader out.

Depth of field preview: Press the depth-of-field preview button in "A" or "M" mode to visually verify the depth of field in the viewfinder.

Flash mounting: Nikon dedicated flash shoe with ISO central contact as well as Nikon System contacts. ISO range for TTL flash is ISO 25 to ISO 1000. Use of flashes made by other manufacturers, especially older models, can damage the camera's electronics by overloading the circuits, and is therefore discouraged by Nikon.

Flash sync speed: Flash will sync at 1/250 second to 30 second; with SB-25 or SB-26 Speedlight, in FP High Speed Sync, from 1/250 second to 1/4000 second using Manual flash mode.

Flash confirmation display: A red LED lights in the viewfinder when the Nikon System flash is ready. It blinks if flash output was inadequate to correctly illuminate the scene or if there was improper contact between the flash and the hot shoe.

Camera power source: Four 1.5v alkaline AA-type batteries, or 4

rechargeable NiCds of the same size. Can be powered by optional MB-10 power grip which accepts four AA or two CR-123A type lithium cells.

Battery power confirmation: LCD panel and viewfinder will display approximately 8 seconds when the shutter release is touched. Noticeably shorter display times are good indicators of low battery power. Additionally, a battery power display symbol is located on the LCD panel.

Dimensions: Width: 6.5 inches (154 mm). Height: 4.5 inches (106 mm). Depth: 2.8 inches (69 mm) or 3 inches (71 mm) with Data Back.

Weight: 27.7 ounces (775g), without batteries.